Calligraphy Today

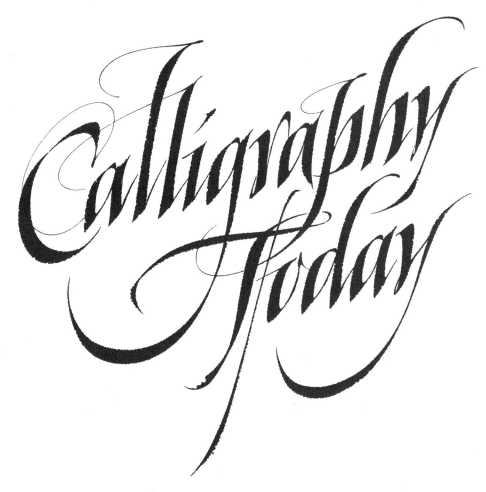

Calligraphy Today

Twentieth-century tradition and practice

Heather Child

Taplinger Publishing Company

New York

First published in the United States in 1988
by Taplinger Publishing Co., Inc.
New York, New York

ISBN 0-8008-1206-9

First edition of *Calligraphy Today* was published 1963 by Studio Books, London
Second edition in 1979 by Taplinger, New York

Filmset by August Filmsetting, Haydock, St Helens

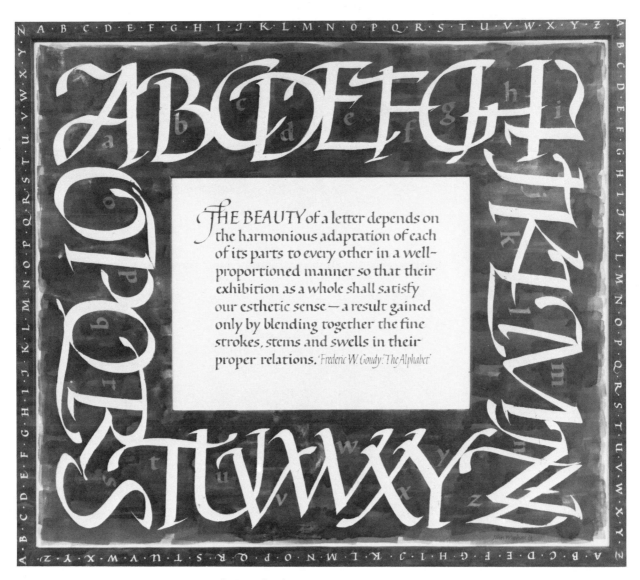

John Woodcock
'The Beauty of a Letter': quotation from *The Alphabet and Elements of Lettering* by
Frederic W Goudy. Centre panel written with a metal pen in brown ink on Whatman
paper. Large border with brush-drawn letters in gouache resist on a yellow, brown
and green background. Barcham Green paper mounted on 4-sheet card. Outer
border in similar colours, pen letters, masking fluid resist. Mounted on 14-sheet
card. 19⅛″ × 22¼″ (48.5 × 56.5 cm). 1985

Contents

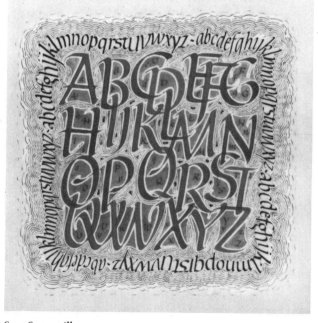

Sam Somerville
Alphabets. Written and drawn on calfskin vellum with stick ink and watercolour. Vellum then stretched on support whose colour shows through. Various types of gilding. 15 cm square (5¾″ square). 1984

Preface

The aim of this book, the third of its title, is to outline the story of twentieth-century calligraphy in words and illustrations, so that a complete newcomer to the subject may grasp the logic of past and present practice and have a view of the range of works that have been carried out in the period. (These include unique manuscript books and panels for exhibitions and collectors, works for ceremonial occasions, graphic designs for reproduction and self-expressive calligraphy.)

At the time of the first *Calligraphy Today* (1963) there were few illustrated books on the work of scribes and the popularity of exhibitions was yet to come. Since those days, the number of books on the subject has grown greatly and is now almost bewildering. However, the continuing demand for another *Calligraphy Today* is justification, for it has been in print somewhere ever since it first appeared.

The century is some twenty-five years on since the original publication and this gives a fresh vantage point from which to look back on accomplishments and trends, and forward to the future.

The text has been planned to give a brief recapitulation of the story of the Revival in England, of its extension – or parallel developments – in other European countries and in America; also to show the national characteristics and range of work produced by calligraphers from around 1900 to the present day.

There are specially-written contributions from three dedicated teachers who are also distinguished scribes: Ann Camp in Britain, Villu Toots in Estonia and Sheila Waters who is now based in the USA. They each depict the calligraphic scene from their individual viewpoints.

While the basic historical background and the story of the Revival under Edward Johnston have not altered, it is natural that the emphasis on certain aspects changes with time and new techniques. This edition is designed to continue the pattern of chronological sequence and to be an illustrated survey of the progress of the craft.

The illustrations should be considered the heart of the matter, bringing together work by those many scribes who have furthered the development of calligraphy either by the quality of their own work or by teaching or by writing on the subject. A balance has been kept between the work of the pioneers, the middle years of the century and recent examples that have a more 'international' flavour. The 'cult of the new' lures us to stress recent activity but much can be learnt from the work of less familiar scribes who are not generally known today.

Photographs are so often taken in colour that the actual availability of good black and white photographs of calligraphy has been a factor in the choice of the illustrations. With reluctance, lettering examples from crafts such as glass engraving, metalwork, woodcarving and stonecarving have not been included for reasons of space.

Calligraphy is an elusive subject to define and therein lies something of its richness and appeal. The Greek word 'calligraphia' means beautiful writing. The term covers more than the art of formal writing with pen and brush, for it embraces cursive handwriting, too, if this has grace and legibility. The meaning of the words written can impose a discipline upon their form for, as with notes in music, letters and words are linear and sequential. The human eye, in the same way as the ear, can absorb different themes, textures and colours simultaneously when scale and design are rightly handled.

Opposite page
Villu Toots
Written in white gouache on tallow-prepared black paper. 28.5 × 21 cm ($11'' \times 8\frac{1}{4}''$).

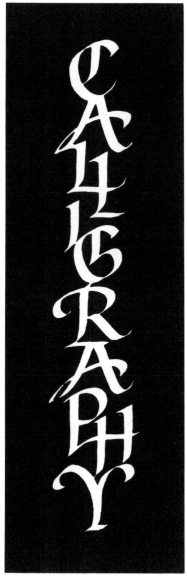

Heather Child
The word CALLIGRAPHY written with a reed pen and black ink on white paper. Reversed. 9″ (23 cm) high. 1975

After speech, alphabets are the most vital bridges between people, and in literate societies almost everyone is taught to write.

The alphabets we use, compounded as they are of history, principles and expediency, were invented to record events, honour the gods and transmit knowledge. They are a marvellous instrument and the many civilisations to which they belong are based on written records in all the many spheres of learning.

In earlier times, when books were entirely made by hand, they were rare, expensive and precious and it was normal for craftsmanship to be expended on the form of the letters and the arrangement and decoration of the written page. The letterforms of the Latin alphabet go back to classical Roman sources and the reed and quill are the ancestors of the broad pens used by modern calligraphers.

The advent of printing changed the making of books and the status of scribes but did not for centuries remove the necessity of handwriting for commercial as well as for private purposes. Typewriters, telephones and computer technology have now done so. What relevance has calligraphy in the climate of today's technological society, when machines do as much of the work as hands used to do?

Calligraphy has a beauty and a meaning not to be seen on computer screen or print-out. (It is interesting to note that typeface corporations now seek the help of calligraphers because of their understanding of letterforms.) It gives pleasure to many who do not practise the craft themselves and, as the appreciation of fine writing increases, so does the realisation of its enhancement of everyday life.

The long-held belief in Britain that calligraphy was only for the rare, the ceremonial and the particular work – two great wars earlier in the century led to wide demand for memorial books to the fallen where discipline and accuracy were essential – took time to relax its hold. Scribes in Britain did not immediately venture into the much larger field of graphics and related book arts, in which earning a living was rather less precarious though never easy.

Perhaps the most visible development since 1976 (when the second edition was published) has been the popularity and international growth of exhibitions featuring calligraphy and the lettering arts. This has both encouraged and paralleled the increase of so-called expressive calligraphy. This term covers widely differing examples, decorative alphabets and texts written with a freedom of style, colour and form that could hardly have been imagined thirty years ago. In some works the legibility of text or even any literary message may be discarded in favour of aesthetic ideals, more related to abstract expressionism perhaps than to fine writing. This intoxicating freedom can enmesh some artists in a tangle of dramatic penmanship with no message but itself.

Another development has been the popularity of workshops, courses and conferences held expressly for the teaching of penmanship and the mastering of techniques, as well as engendering enthusiasm among the hundreds of aspiring calligraphers – in America, Canada, Europe, Britain and Australia – who are the informed supporters of the craft. Although one should expect this ferment to produce the next generation of fine calligraphers, the future of this 'useful and delightful' craft is in peril.

Often have the master penmen of this century stressed the value of understanding letterforms, of mental discipline and manual skill, of intuitive delight and spontaneity in execution. These skills flow into other areas of creative achievement, for learning to form letters and to write well is a basic training for visual design, in typography and printing, and in many manufacturing and marketing endeavours. The essential development

needed is a rekindling of this faith among the principals of Art Schools.

Unless the art and craft of lettering are adequately appreciated, learnt and taught in art schools there will not be the informed teachers to satisfy even the hunger of the many amateur calligraphers, let alone keep alight the beacons of excellence.

The achievements of the Revival this century which are chronicled and demonstrated in this book could be lost if the chain of teaching and learning is not sustained.

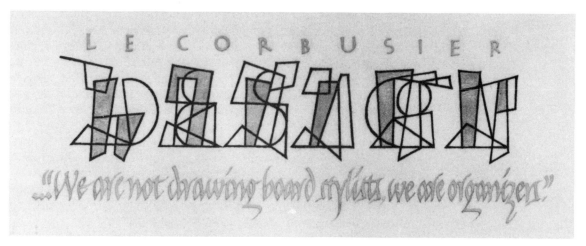

Ewan Clayton
Design. Written on vellum with top and bottom lines in grey gouache, centre in dark red gouache with panels of shell gold. The point of departure for the stresses, weights and volumes of the central letters is an expression of the Angle, Weight and Form of double-pencil written originals. The letters in the top line are organised on the basis of a modular line unit. The letters in the bottom line are organised on the basis of a movement. 8×18.5 cm ($3'' \times 7\frac{1}{4}''$).

Acknowledgements

Acknowledgements are due to the many people who have helped in the compiling of this book and without whose help it could not have come to completion. I should like to thank particularly all those who have lent manuscripts for the illustrations; also the Trustees of the Victoria and Albert Museum, the British Library, the Bodleian Library and the Crafts Study Centre at Bath for permission to reproduce works in their collections; also Ann Camp, Sheila Waters and Villu Toots who have written articles for this new edition. I am grateful for the generous assistance and advice of Stan Knight, Rick Cusick, Justin Howes and Dorothy Colles. Finally special thanks are owed to Anne Watts for her patience and care in the editing and production of the book.

H. C.
January 1988

Note Dimensions given in captions are those provided with the original, followed by the metric or imperial equivalent. Some image areas may have been cropped to fit the available space.

Elements of the craft

Through the centuries individual formal hands have reflected something of the architecture and design concepts of the period in which they flowered, and the characteristics of its writing help to establish our sense of a given period. For instance, the Gothic letter – romantic, angular and ornamental – produces an entirely different feeling from the rounded, classic, well-balanced Roman letter, and the cursive hands are in sharp contrast to both. The informed calligrapher, enriched with a knowledge and understanding of the proportions and construction of the letterforms characteristic of these different periods, does not copy them slavishly. Selecting a hand suited to his purpose, he will study, develop and adapt it to the occasion for which the manuscript is being made – whether it be ceremonial, solemn or festive. With a basic understanding of tradition, which acts as a springboard for his own skills, he will aim to produce a result which belongs entirely to his own time.

For the beginner, therefore, an appreciation of the fundamental principles of calligraphy and a sound knowledge of the basic techniques in acquiring a formal hand are of first importance. The form and construction of letters can only be properly understood by using the tools of the craft and the scribe requires singularly few – writing instrument, ink and writing surface are the three essentials.

Pens may be broadly divided into those that make gradated thick and thin strokes by change of direction rather than pressure, and those that write without variation of thickness. The broad pen used by calligraphers has a writing *edge* instead of a point, and calligraphic metal pens are manufactured today in a wide range of sizes and styles. All nibs need to be kept sharp and clean if they are to make true and crisp strokes. Inks must flow easily without clogging the pen and a good soluble black carbon ink is best in this respect. On the whole, waterproof inks tend to be too thick to flow easily from the pen. Coloured inks do not have the covering power required and may not dry evenly. For practice writing, poster colours and students' watercolours are suitable for colour work. For finished work artists' watercolours in cakes, pans or tubes may be used, or Designers' Gouache which is more opaque.

Good-quality paper with an unglazed surface makes a suitable writing material for ordinary use. If the paper is too smooth the pen will slide over the surface uncomfortably, if too rough the freedom of the pen is in danger and if too porous the ink tends to 'feather' and spread. Well-prepared vellum gives the perfect writing surface for the practised scribe, who is using well-cut quills or metal pens and is aiming at excellence.

In *Formal Penmanship* Edward Johnston wrote:

> In studying any of the many Latin book-hands we find that, notwithstanding their particular differences of shape and size and weight, they are alike in this – every one of them is the natural product of the broad-nibbed pen, and each one of them can be automatically reproduced by us with such a pen, suitably shaped, held and moved.
>
> Besides this common relationship through the broad nib, the different book-hands are all of one family – the Roman... the conventional shapes of the Roman capitals and of the Roman lower case are at present current in most parts of the world. The conventional *italic lower case* is also a widely recognized variety of the Roman alphabet.

These three forms – Roman capitals, Roman lower case, and italic lower case – are therefore of the first importance to the scribe: his main practice is concerned with the shapes – that is, with their characterized essential skeletons.[1]

The calligrapher's concern is to write fluent and legible letters, to space them well when making words and lines and to arrange them intelligently on the page. Are the letters in the chosen style of writing upright or sloping, joined or separate? What is the angle of the thin stroke to the horizontal writing line? Does the script give the impression of strength or stability, elegance and movement, richness or delicacy? The spaces within each letter, the counters, are as important as the spaces between the letters and words. The ability to space well comes by practice and the skilled calligrapher spaces by eye. A trained eye will also recognise whether a script is sound in the construction of its letterforms. Analysis of examples of fine penmanship, whether historical or modern, will help to develop this valuable discrimination.

Edward Johnston
Early Class Sheet, dated 28 June 1901, for which he wrote out a page of Ruskin's fifth Lecture on Art. Writing area 7″ × 5¾″ (18 × 14.5cm).
(By courtesy of the Crafts Study Centre, Bath. 2/390.)

AND he shall be like a The
tree planted by the → happiness
of the
godly.
streams of water
That bringeth forth its
fruit in its season
Whose leaf also does
not wither

AND he shall be like a tree The
planted by the streams of happiness
of the
godly.
water that bringeth forth
its fruit in its season, whose
leaf also does not wither.

Edward Johnston
Trial page for a book of *Psalms* written on vellum with red and black ink in a
modernised half uncial and an early version of the Foundational Hand, *c* 1902. In a
letter to Percy Smith, 1935, Johnston wrote of his early 'modernised' half-uncial
alphabet, 'No such alphabet had existed before, apart from my teaching. It was
myself that "modernised" the old Roman half uncial ... and produced what was
tantamount to an original design for a pen alphabet. *That* (influenced by the *Book of
Kells*) Roman half uncial was the source of my "modernised" form.' (Quoted from
Edward Johnston by Priscilla Johnston, Barrie & Jenkins, London).
(By courtesy of the Crafts Study Centre, Bath. C 74.3.)

The Ink & the Paper

Rick Cusick
The Ink and the Paper. Title used on the dust jacket of a fable written by Richie
Tankersley Cusick and published by Nyx Editions. 1984

In his manual Johnston held that the essential qualities of good writing are *Readableness, Beauty and Character*.[2] Later, in his second book, he defined them as *Sharpness, Unity and Freedom*.[3] In analysing these qualities, however, legibility is fundamental and it is an elusive term, difficult to define. Robert Bridges held that 'True legibility consists in the *certainty of deciphering* and that depends not on what any one reader may be accustomed to, nor even on the use of customary forms, but rather on the consistent and accurate formation of letters.' Each letter has distinct characteristics of its own, but all letters in a given alphabet should have a family likeness which makes for harmony. Contrasts in size of writing, in colour and decoration, all bring interest and liveliness to the page, but they should add to and not detract from the unity of the whole. The factor of legibility will depend on the unity and rhythm in the writing – qualities which come with understanding and practice. Unity is concerned with technique in formal writing. Sharpness results from writing with a well-cut or well-sharpened pen on a well-prepared surface. If attention has been paid to these technical matters, the pen can then be used spontaneously with a sensitive touch to make fluent letters. Writing at a natural speed gives rhythm and vitality to the work. Writing that is too careful will lose these attractive qualities.

The first consideration of the scribe should be to the thought or image intended by the author of the work being transcribed. The planning of a manuscript must obviously take place before the writing-out begins; if the scribe is hampered by technical considerations, or the temptation to show off his own skill, the work will fall short in simplicity and distinction. Frederic Warde held that 'Calligraphy may be defined as the writing of a person who has trained his eye, and his judgement to write habitually according to a rational method,... Calligraphy is most admirable and interesting when a it is done according to its classic rules... The rules aimed at one objective – FORM. Real style is impossible without form.'[1]

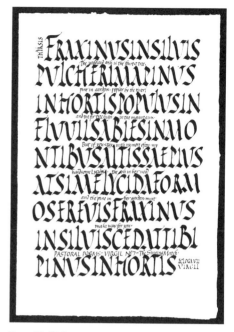

Peter Halliday
Quotation from Virgil, *Eclogue VII*, written in Rustic script. English translation by the scribe in semi-formal italic. Sumi ink on Bodleian handmade paper. 20″ × 14″ (51 × 35.5 cm) 1983.
(By courtesy of Professor and Mrs. David Taylor.)

[1]Edward Johnston: *Formal Penmanship*, page 127
[2]Edward Johnston: *Writing and Illuminating, and Lettering*, page 239 (1908 impression)
[3]Edward Johnston: *Formal Penmanship*, page 142
[4]Frederic Warde: 'Classic definition of calligraphy' from *With Respect... to RED*, edited by Rich Cusick, page 18

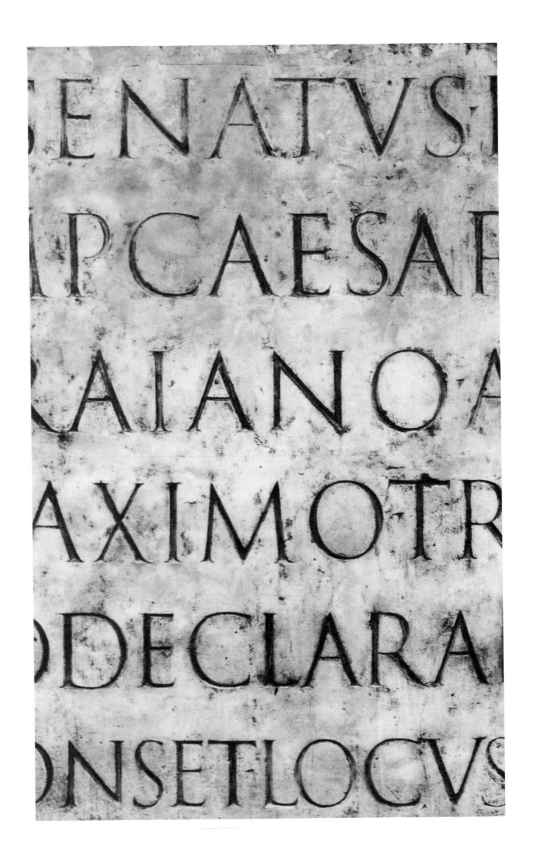

A brief historical background

The interest awakened towards the end of the nineteenth century in the beauty and discipline of historical scripts engendered a creative vitality among pioneers of calligraphy in Britain and Germany and subsequently in America. The resurgence of calligraphy in this century cannot be properly appreciated without a knowledge of the historical hands on which the revival was based and on which many modern styles of writing and typefaces have been based, directly or remotely. A few examples from classical, medieval and Renaissance manuscripts are reproduced in this chapter.

> Nearly every type of letter with which we are familiar is derived from the Roman capitals, and has come to us through the medium, or been modified by the influence, of the pen. And, therefore, in trying to revive good lettering, we cannot do better than make a practical study of the best of pen-forms, and learn at the same time to appreciate the forms of their magnificent archetypes as preserved in the monumental Roman inscriptions.[1]

The Roman letters of classical times show clearly the formative influence of the tools used in making them. These tools were the stylus on wax and clay; the square-cut brush and chisel on stone; the reed and quill on papyrus or skin. The arrangement of thick and thin strokes and the shape of the curves are largely determined by the instrument used in the making of the letters and the angle at which the instrument is held when letters are written.

Rustic and Square capitals

The principal formal hands used in early book production were written in capital letters or, to use the palaeographical term, majuscules. These Latin book-scripts, Rustic and Square Capitals, consist of letters written between two imaginary parallel lines without ascending or descending strokes. The Rustic Capitals of the same period as the Square Capitals (or perhaps earlier) were written more freely than the Square Capitals of the fourth-fifth centuries, the pen being held at a steeper angle to the writing line, thus compressing the letters more closely together and making the down strokes of each letter thinner in width. It would appear that these two scripts were primarily used for writing classical texts.

> It has long been assumed that Rustic capitals were a degenerate form of written Square capitals, but the recent discovery of an ancient Rustic script (the pre-Christian Gallus Papyrus) indicates that the two styles in fact developed independently. It may be that Rustic capitals even pre-date the Square in manuscript use.[2]

Roman Cursive writing

During the period when these formal capital letters were used for writing books, Roman informal or cursive writing gradually developed from them and was used for documents, letters and similar commonplace purposes. It was mostly written on wax tablets and papyrus and it was natural for scribes, when writing on these materials at speed, to alter the formal shapes of letters in order to economise on effort. These more freely written forms influenced the development of 'minuscules' or small letters, which

[1]Edward Johnston: *Writing and Illuminating, and Lettering*, chapter 1 page 1 (1980 imp.)
[2]Stan Knight: *Historical Scripts*, introduction fig. 4
[3]Stan Knight: *Historical Scripts*, introduction fig. 5
[4]E A Lowe: *English Uncial*, page 2

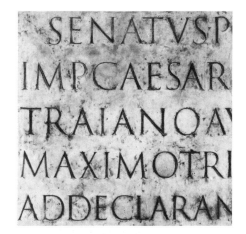

Roman inscriptional capitals.
Monumental lettering from the marble panel on the pedestal of Trajan's column, Rome. These majestic letters range in height from 4½″ (11.5 cm) in the top two lines to 3⅞″ (10 cm) in the base line – when viewed from the ground all the letters appear to be the same height. A.D. 113 (See *The Trajan Inscription in Rome*, by E M Catich, Catfish Press, Davenport, USA 1961.)

Rustic capitals.
'This manuscript is usually assigned to the 4th or 5th century A.D., but recent evidence suggests that it is more likely to be a 6th-century copy of an earlier Rustic Virgil.' (*Historical Scripts*, by Stan Knight) From the *Codex Palatinus* (works of Virgil), Vatican Library, MS. Pal. Lat. 1631.

Opposite page
Roman inscriptional capitals
See caption at top of this page.

VTCVMTEGREM
REGALISINTER
CVMDABITAMP
OCCVLTVMINSI
PARETAMORDIC
EXVITETGRESSV
ATVENVSASCA
INRIGATETFOT
IDALIAELVCOSV

Above

Square capitals.
Written Square capitals are closely related
to inscriptional Roman capitals in their
letterforms and in their spacing. The letters
are $\frac{1}{4}$" high. 5th century A.D.
From the *Codex Sangallensis* (works of
Virgil), Library of St. Gallen, Switzerland,
MS. Cod. 1394.

Above right

Roman cursive writing.
Example on papyrus. 5th century A.D.

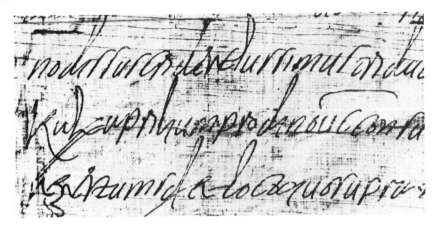

became distinct from 'majuscules' or capital letters. (Later, when printing
was invented, majuscules were called upper-case and minuscules lower-
case, a usage which continues today. The term derives from the two com-
partments in the traditional compositor's case in which his type is kept,
the upper case containing capitals, the lower case containing small
letters.)

Uncials

A third hand used by the Romans was Uncial with its beautifully rounded
forms. It was mainly used for Christian books from the fourth to the eighth
century. Letters of Uncial appearance emerge very early in a mixed hand of
about A.D. 100 found in Egypt.[3] These Uncial letter shapes have their
origins in Old Roman Cursive writing, cursive thus being elevated to a
higher status. Later Latin Uncials may also have been influenced by Greek
forms when the Bible was translated from Greek into Latin.[4]

The Uncial script was introduced, or reintroduced, into England with St.
Augustine's mission of A.D. 597, after which Canterbury soon became a
seat of ecclesiastical importance. Missions from Rome to the north of
England during the seventh and eighth centuries led to the founding of the
Northumbrian monasteries of Wearmouth and Jarrow. Whereas earlier
forms of Uncial were written with a slanted pen and later ones with a

Roman uncials.
Probably written between A.D. 725 and 750 at St. Augustine's monastery, Canterbury.
The interlinear gloss was added about a century later. (This monastery was founded
by missionaries from Rome shortly after St. Augustine's mission of 597.)
From *The Vespasian Psalter*, British Library, Cotton Vesp. MS. A. i.

straight pen, both pen angles were used in these monasteries to produce two of the most famous Uncial manuscripts, the Codex Amiatinus and the St. Cuthbert (Stonyhurst) Gospel.

Uncials were truly a penman's alphabet and have proved to be popular as inspiration for modern work.

Half-Uncials

Half-Uncials mark an important step in the history of writing. They have their tentative beginnings in early mixed hands of the third century[5] and date from the fifth to the eighth century.[6] They have the roundness of Uncials and were the forerunners of the later fully-developed minuscule forms of writing. Half-Uncials were written with ascending and descending strokes. The letters were made between four imaginary lines instead of two and the pen was held with its edge straight to the line of writing. In the course of time writing developed marked national characteristics: Beneventan in southern Italy, Merovingian in France and Visigothic in Spain.

The correct terminology for scripts is rather confusing for those who have not studied palaeography and therefore it seems appropriate to quote a paragraph from B L Ullman's book *Ancient Writing and its Influence*.

> There is a difference of opinion whether one should speak of half-uncials as minuscules or majuscules. Like so many other controversies, this one is due to variation in definition and use of words. If by minuscules we mean letters which are clearly to be written between four lines instead of two, then half-uncials are minuscule. The same is true if we test this writing by the shapes of the letters or their relatively smaller size. If we mean by minuscule a script which is used in the body of the text while another style is used for running heads, then both uncials and half-uncials are minuscule, for in uncial manuscripts we find running heads in rustic or square capitals, and uncial titles are found in half-uncial manuscripts. It is true that in later times half-uncial was thought of as a script suitable for titles for a minuscule text, but that does not make it majuscule any more than lower-case italics or black-face letters are majuscules when we use them in headings. The difficulty is that extreme forms of majuscules and minuscules are easily distinguished while intermediate forms are not.[7]

The coming of Christianity to Ireland in the fifth century brought the culture of Europe to that remote country and the Irish Half-Uncial developed out of early examples of Roman Half-Uncial (Uncials never went to Ireland).[8] Irish Half-Uncial is seen at its best in the incomparable *Book of Kells* written in the eighth century.

From Ireland, Christian culture spread to Britain, in particular to Iona and Northumbria. It was in Northumbria that an Anglo-Saxon variety of Insular Half-Uncial developed. The magnificent *Lindisfarne Gospels*, completed in *c* A.D. 698, is the outstanding illuminated manuscript written in this script.

This was to be the first style of early writing modernised by Edward Johnston and used as a copy-book hand for his students. He said of it that:

Its essential roundness & formality discipline the hand. Its elegance (due to the gradation in its horizontal curves) has an aesthetic value that fits it for certain MS. work, but unfits it for many *practical* uses where thin parts are liable to damage (e.g. as a model for type or letters formed in any material, or to be read at a

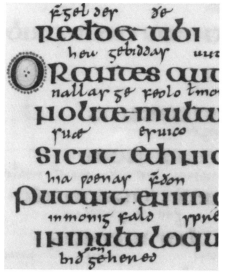

Roman half-uncials.
A script which dates from the beginning of the 6th century A.D.
From St. Hilary's *De Trinitate*, a version probably written at Cagliari before A.D. 510, Vatican Library, Archivio della basilica di S. Pietro, D. 182

Anglo-Saxon half-uncials.
Written at Lindisfarne, Northumbria, *c* A.D. 698. The interlinear gloss was added at Chester-le-Street *c* A.D. 950.
From *The Lindisfarne Gospels*, British Library, Cotton MS Nero D. IV.

Below left

Rustics, Roman capitals, uncials, Caroline minuscules.
Written at the Abbey of St Martin, Tours, France, between 825 and 850, following the period when Alcuin of York was superintending there the revision of Church books. The Caroline minuscule is a beautifully legible script which can be written very small and rapidly, its slight slope forward giving it a cursive quality. From *The Grandval Bible*, British Library, Add. MS. 10546.

Below right

English Caroline minuscules.
Written in England, possibly in the cathedral priory at Winchester or at Ramsey, *c* 947–986. The heading is written in red Rustic capitals and the versal initial in gold. Edward Johnston recognised that this manuscript would provide an almost perfect model for a modern formal script and used it as a basis for his Foundational Hand. From *The Ramsey Psalter*, British Library, Harley MS. 2904.

distance). For such purposes the 'slanted-pen' character is better... It is in effect *the 'straight pen' forms of the 'roman' small letter* (that is, practically, the Roman Half-Uncial) ... It therefore represents the ancestral type of small-letter, and is a good basis for later hands.[9]

Caroline minuscule

In the history of formal handwriting the Age of Charlemagne is of far-reaching importance. In A.D. 789 the Emperor Charlemagne, who greatly influenced the religious and cultural life of his time, decreed the revision of Church books, and this intensified activities in the monastic writing schools in France. There was an awakened interest in the classical culture of Rome and in learning generally, including Biblical studies. This led Charlemagne to invite many learned men and scholars to his court, among them Alcuin of York who was born *c* A.D. 735. After spending several years teaching at the Palace School he was appointed by Charlemagne as Abbot of St. Martin's in Tours, where he remained for eight years until his death in 804, and where he encouraged and established the clear, fluent script which came to be known as the Caroline or Carolingian Minuscule. In its best-known form this script has features that are cursive, such as the slight slope forward and the absence of pen lifts between the strokes of some letters. It is a hand of outstanding legibility, rhythmical beauty and importance; lower-case letters of today derive from versions of it and for centuries it remained the dominant hand of the West.

During the tenth century, particularly fine variations of the Caroline minuscule came to be used in southern England. The emergence of these

[5]Stan Knight: *Historical Scripts*, introduction fig. 1

[6]B L Ullman: *Ancient Writing and its Influence*, page 74

[7]B L Ullman: *Ancient Writing and its Influence*, pages 75–6

[8]E A Lowe: *English Unciâl*, page 6

[9]Edward Johnston: *Lessons in Formal Writing*, note printed at foot of illustration on page 116 (reproduced from plate 4 of *Manuscript and Inscription Letters* which is no longer available)

hands was the result of the Benedictine monastic revival, based on continental reforms, which led to a significant increase in the making of books. They were strong hands of developed formality and Edward Johnston considered the Harley MS. 2904, or *Ramsey Psalter*[10] written about 974–986, an almost perfect model for formal writing, because of the large size of its writing, logically-made letterforms and consistent pen angle. He developed a modernised version of it using the broad pen, which he called the Foundational Hand; this became the basis of his later teaching and he wrote many of his own manuscripts in it.

In the eleventh century letters began to get narrower preceding the emergence of Gothic scripts. A very fine transitional or proto-gothic script was written by Eadui Basan at Christ Church, Canterbury, and was used by him for both books and charters.[11] This hand shows a considerable amount of pen manipulation particularly at the bottom of letters. It has been successfully used as a basis for modern hands by a number of people.

Gothic scripts

By the twelfth century, with certain exceptions, the Caroline minuscule was on the way to becoming Gothic. The term Gothic is usually applied to the art and architecture of western Europe in the latter part of the Middle Ages – the period starting in the thirteenth century and continuing until the Renaissance in the fifteenth century. Gothic scripts, both formal and informal, varied in style, vitality and legibility from region to region throughout this period. The chief characteristics of the Gothic book hands are 'lateral compression, heavy weight and sharp angularity'.[12] Many of the compressed, ornamental 'black-letter' hands became mechanically rigid and lifeless, in marked contrast to the Caroline hands from which Gothic derived. In Italy and Spain a rounded Gothic script evolved, aptly named Rotunda, which avoided excessive angularity and was used in small Books of Hours and most successfully in huge manuscripts for liturgical use.

Gothic styles of writing and printing have persisted into this century in Germany, but have now been almost superseded for general use by the roman letter, although incorporated in decorative work by modern scribes.

Humanist hands

The Humanist scholars of the Renaissance, searching for works of the classical authors, came upon manuscripts written in Carolingian hands, some of which were written as late as the twelfth century,[13] and they termed these hands 'littera antiqua' and adapted them for their own use. Such versions of Carolingian hands are called Humanist. In addition to their interest in manuscripts the Humanists studied the classical Roman inscription letters, adapting them for writing, lettering and type.

During the Renaissance in Italy a variant of the Carolingian hand was developed which we know as Italic. Its original characteristics were those of a cursive handwriting, the result of speed, rhythm and economy of effort; later, the hand became formalised. It was used in manuscript books, in correspondence and for the numerous Papal briefs sent all over Christendom and was known as 'cancellaresca' or chancery script.

> By difference in the usage of the revived caroline script it became, on the one hand, the very legible, noble, and serene Roman letter of developed structure and formality, whilst on the other it grew into the fluent, elegant, and spirited italic, executed with a precision ranging from a copy-book standard to complete informality.

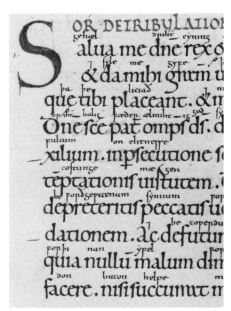

Compressed English minuscules.
Written out by Eadui Basan, scribe of Christ Church, Canterbury, between 1012 and 1023. The interlinear Anglo-Saxon gloss was added soon after.
From *The Arundel Psalter*, British Library, Arundel MS. 155.

Gothic script.
Written in England in the late 12th century. From an Office Book of episcopal rites, British Library, Cotton MS. Tib. B. VIII.

Et quascunque tulit formosi temporis eras
Cynthia non illas nomen habere sinat

Nedum si leuibus fuerit collata figuris
Inferior duro iudice turpis eat

Hec sed forma mei pars est extrema furoris
Sunt maiora quibus basse perire iuuat

Ingenuus color & multis decus artibus & que
Gaudia subtacita dicere ueste liber

Quo magis & nostros cotendis soluere amores
Hoc magis accepta fallit uterque fide

Non impune feres sciet hec insana puella
Et tibi non tacitis uocibus hostis erit

Nec tibi me posthec comittet Cynthia: nec te
Queret: erit tanti criminis illa memor

Et te circum omnis alias irata puellas:
Deferet heu nullo limine carus eris

Nullas illa suis contemnet fletibus aras
Et quicunq sacer: qualis ubique lapis

Non ullo grauius tentatur Cynthia damno
Quam sibi cum rapto cessat amore deus

Precipue nostri maneat sic semper adoro
Nec quicq ex illa quod querar inueniam

Humanist minuscules.
Written by Antonio Sinibaldi, *c* 1480. Graily
Hewitt particularly admired the
manuscripts of Johannes Andreas de
Colonia and Antonio Sinibaldi.
From *Elegies* by Propertius, Bodleian
Library, MS. Canon Class. Lat. 31.

The humanistic cursives of the fifteenth century were at times rounded, in the style of the Caroline script, but later became narrower. The narrower letter was at first curvilinear but later sometimes pointed. Eventually the italic hand developed into the copperplate hand.[14]

Printing

The process of printing with movable type which, in spite of computer technology, is still sometimes used today, was invented for the Western world by Johann Gutenberg of Mainz, between the years 1440 and 1450. The first substantial volume to come from a printing press was the Latin Vulgate Bible. It was planned and printed (whether wholly or in part only) by Gutenberg. 'History can show no more pregnant mechanical innovation than Gutenberg's. Its potentiality for infinite multiplication of the written word revolutionised man's capacity for the exchange of ideas.'[15] The early German typefaces were based on the formal Gothic book hands. In Italy, however, typefaces were inspired by the open and more legible styles of the revived Caroline minuscule and Roman capital letters. It is hard to imagine more noble models for the design of typefaces at the outset of printing and it is understandable that the early printed books were modelled on manuscripts.

The first writing manual, *La Operina*, was produced in Rome in 1522, by Ludovico degli Arrighi of Vicenza, who was a writer of Papal briefs. His manual offers instruction in writing the cancellaresca hand and is printed from wood-cut blocks (the background was cut away and the letters left raised). It has been a source of inspiration to many modern calligraphers. Arrighi followed *La Operina* a year later with a second book *Il Modo*, cut and printed in Venice, it showed model hands for a variety of purposes. Giovanni Antonio Tagliente's writing book of scripts and alphabets followed in 1524, and that of Giovanni Battista Palatino in 1540. The popularity of these aids to good handwriting encouraged similar exemplars to be produced in other countries – France, Spain, Germany, the Netherlands and England. Calligraphers in the twentieth century have continued this practice by producing their own writing manuals, some of which are listed in the bibliography of this book.

From classical times to the invention of printing, the broad pen played the most significant part in the development of letterforms for formal and cursive penmanship. The earliest aim of the printer was to produce books resembling closely manuscripts written in the formal book hands.

Following the invention of printing, the long tradition of copying books by hand on papyrus, parchment and paper was broken and the standard of formal penmanship declined. Many of the professional scribes became Writing Masters, who produced handsome, engraved writing books in which to display a variety of hands and teach them to others. During the eighteenth and early nineteenth centuries, the professional penmen – scriveners and law writers – were still a commercial necessity and a part of everyday life. They wrote with a quill, and later with the pointed, flexible, metal pens that came into general use in the 1830s.

[10]Edward Johnston: *Writing and Illuminating, and Lettering*, plate 8
[11]Edward Johnston: *Writing and Illuminating, and Lettering*, plate 9; also Stan Knight: *Historical Scripts*, C8
[12]Stan Knight: *Historical Scripts*, D1
[13]Edward Johnston: *Writing and Illuminating, and Lettering*, plate 10
[14]Alfred Fairbank: *A Handwriting Manual*, page 17
[15]*Printing and the Mind of Man*, catalogue of exhibitions at the British Museum and Earls Court exhibition centre 1963, page 17

The art of the book was revolutionised by the introduction to England of colour printing by chromolithography in the 1880s. Magnificent illuminated volumes were produced in colour by Henry Shaw, Owen Jones and Noel Humphreys among others, with pages reproduced from medieval manuscripts. These were followed by popular books on illumination which usually contained plates drawn in outline for hand colouring, and primers with some colour reproductions of illuminated initials and decorative borders. This was the period of the Gothic revival in architecture and ornament in Victorian Britain, whose romantic concept of medievalism was a movement which later became generally popular in Europe and America.

The invention of printing did not completely destroy the art of formal penmanship, nor the art of illumination. Manuscripts such as grants of nobility, letters patent, diplomas and tables of genealogy, have continued to this day to be written and richly decorated by hand.

By the mid-nineteenth century, however, the creative arts and crafts were at a low ebb and the standard of type design and book production had seriously deteriorated. It was around this time that the revitalising influence of John Ruskin and William Morris on the art of the book began to be felt – the scene was set for the twentieth-century revival of calligraphy.

Acknowledgement I should like to thank Ann Camp for reading this brief historical background in draft form, for compiling notes and references on several aspects of the history of writing, for making a number of recommendations and for her general co-operation and help. Any mistakes are, of course, my own responsibility. H C

Chancery cursive.
Written in Rome by Ludovico degli Arrighi, a professional scribe employed by the Papal Chancery, *c* 1517. This rapid style of italic writing was developed for briefs and other less formal documents.
From *The Apologues of Pandolfo Collenuccio*, British Library, Royal MS. 12C VIII.

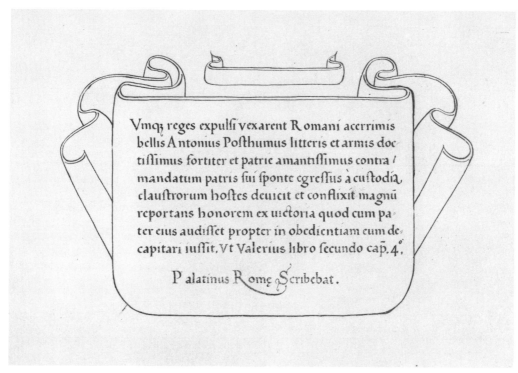

Humanist minuscules.
From a handwritten specimen book by Giovanni Battista Palatino, Rome, *c* A.D. 1540.
The book contains examples of Chancery cursive and Humanist minuscules based on the earlier Caroline minuscules.
Bodleian Library, MS. Canon Ital. 196.

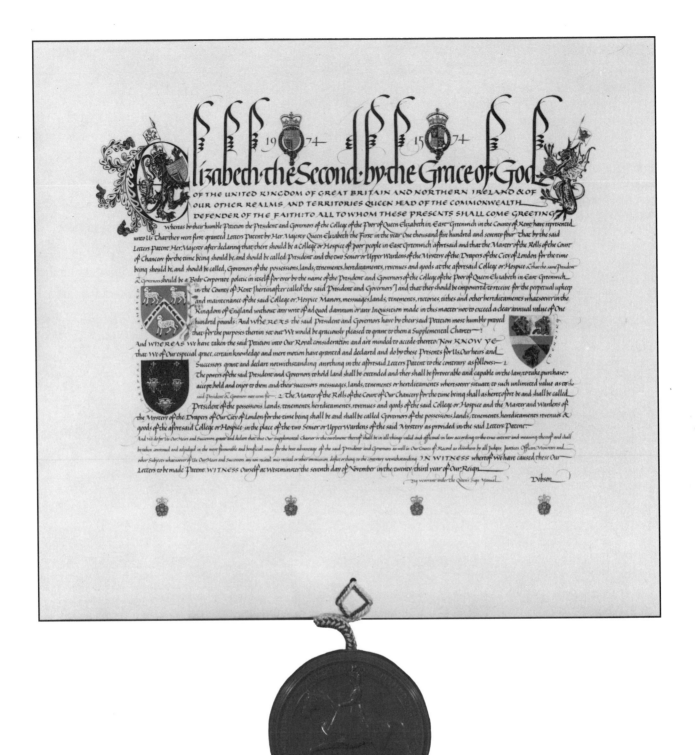

Calligraphy in Britain

Pioneers of the Revival and Early Years

Asurvey of the tradition and practice of twentieth-century calligraphy, however brief, must begin with William Morris and the Arts and Crafts Movement. This was a movement born of the political and artistic aspirations of the late nineteenth century and, on a practical level, took the form of a revolt against the shoddiness of the products of the Industrial Revolution.

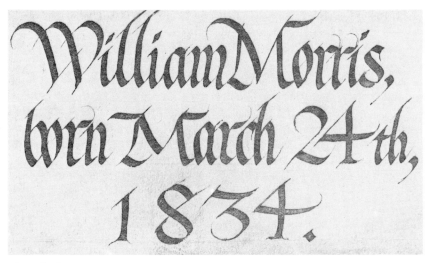

Edward Johnston
Inscription placed with a laurel wreath 24 March 1934 to mark the centenary of the birth of William Morris. The wreath was laid beneath a portrait of Morris at the Morris Centenary Exhibition. Black ink. 8.3 × 17.8 cm (3¼″ × 7″).
(Victoria and Albert Museum, Circ. C 11057.)

William Morris, 1834–1896, was a poet, writer and Socialist. From 1861 he made designs for wallpapers, glass, textiles, tapestries and print. He was already interested in early manuscripts and he himself owned several, among them a unique variant of Arrighi's *La Operina* and *Il Modo*, in one volume. Between the years 1870 and 1876 he experimented with writing and decorating books in the style of Medieval and Renaissance scribes, some of them in collaboration with the artist, Burne-Jones. These fine manuscript books are few in number and some remain unfinished. Among the best are a Horace (in the Bodleian Library, Oxford), a Virgil and two copies of *Omar Khayyam*. Some of these manuscripts were exhibited in the first exhibition of the Arts and Crafts Exhibition Society in 1888, the year of the society's foundation.

Morris used various scripts, mainly semi-formal and cursive Roman hands in which he showed a rhythmical quality but a lack of understanding of the shapes of letters and their inner relationship. Nevertheless it was his manuscripts that led to the calligraphic reforms of the twentieth century and his studies that opened the way to the Revival. Alfred Fairbank was to say of him, 'Morris could well be described as a complete bibliophile: author, scribe, illuminator, engraver, type designer, printer, publisher and collector.'

In 1890 Morris founded the Kelmscott Press at Hammersmith, west London, together with Emery Walker who was a typographical expert, process engraver and antiquary. In many ways this Press was the major

Opposite page
Donald Jackson
Supplemental Charter: Letters Patent of the Worshipful Company of Drapers' Almshouses in Greenwich, Queen Elizabeth College. 1974

achievement of Morris's life, and for it he designed type founts, ornamental letters and borders. Fifty-three books were produced by the Press, of which the best known is the Chaucer.

Also in 1890 T J Cobden-Sanderson, a printer and bookbinder who was very active in the Arts and Crafts Movement, founded the Doves Press. The two Presses were both devoted to the improvement in the standard of book production from its sad state at the end of the nineteenth century. Following their success, other private presses were started in Britain and in other European countries. Many of the books produced were outstanding – calligraphers were specially commissioned to design type and decorative or written letters for them.

In his *Book Beautiful*, Cobden-Sanderson emphasises that Morris was a calligrapher and an illuminator before he became a printer but that his influence was greater in the field of printed books than in manuscripts. His craft ideals of simplicity, beauty and fitness for purpose were much in advance of his period. Ruskin said of him, 'Morris is beaten gold – the most versatile man of his time.'

Yet it was at this time that Victorians with an ecclesiastical interest in illuminated texts were copying Gothic letters in outline with a mapping pen, then filling the letters with a brush. They totally missed the spontaneous strokes of the broad pen, essential to true formal penmanship.

Edward Johnston, 1872–1944, first came to London as a young man at the end of 1897 with the intention of 'going in for art'. Through William Cowlishaw, an architect, he soon began to meet people influential in the Arts and Crafts Movement, notably Sydney Cockerell who had been four years secretary to Morris, and William Richard Lethaby who was a younger friend of Morris. Both men encouraged Johnston to study in the British Museum and it was Cockerell (who was becoming an authority on illuminated manuscripts) who gave him advice on which early manuscripts to choose and showed him manuscripts in his own collection.

Johnston carried out this research with the perception of a craftsman and the perseverance of a philosopher and scientist. He recognised that the nature and form of a letter are determined by the nature of the pen that makes it, that a broad pen makes thick and thin strokes according to the direction and angle at which it is held and not according to pressure, and that the size of the letter should be in direct ratio to the breadth of the pen that makes it. He worked out for himself how to cut and sharpen reeds, bamboos and quills, and the angle at which to trim the chisel edge of the pen. Also what angle there should be between the edge of the pen and the horizontal writing line if letters are to have the desired shape. He experimented with the preparation of the surface of skins and with inks and pigments. The rediscovery of these lost skills was a triumph at the time.

William Richard Lethaby, 1857–1931, architect, designer and educationalist, was a founder of the Central School of Arts and Crafts, London, and its first Principal; he believed that crafts were a vital necessity within an industrialised society. In choosing staff for his new school he drew on contacts with the Arts and Crafts Movement through his membership of the Art Workers Guild, founded in 1884, and the Arts and Crafts Exhibition Society founded in 1888.[1]

One of his most perceptive appointments was to put Johnston in charge of the 'illuminating' class with far-reaching results.

[1]Theresa Gronberg: *W R Lethaby and the Central School*, 1984

This class started in September 1899 with seven or eight students who included: T J Cobden-Sanderson who was older than the others; Eric Gill, then a very young man, who later became renowned as a sculptor, engraver and letterer; Noel Rooke who was to engrave illustrations for Johnston's *Writing and Illuminating, and Lettering* (1906); Douglas Cockerell's wife and Emery Walker's daughter. Within a year their number increased to include Louise Lessore, who married Alfred Powell, Graily Hewitt, Laurence Christie, Percy Smith and Florence Kingsford (Mrs Sydney Cockerell) who is known for her fine illuminations.

Priscilla Johnston, in the biography of her father (*Edward Johnston*, 1959), writes that these early students had 'every reason to regard themselves as pioneers. Together they were a band of explorers in an unknown country… Johnston's goal at this time – even more than to establish himself – was to establish the craft. He envisaged a sort of guild of calligraphers, all studying, experimenting and making discoveries which they would then all share.' A short-lived Society of Calligraphers was formed, of which Percy Smith was honorary secretary. Eric Gill, Edward Johnston, Philip Mortimer and Allan Vigers made up the executive.

Percy J Delf Smith
Detail from Plate 12 of *Portfolio of Lettering and Writing*, published by B T Batsford, 1908. Actual size.

In 1901 Lethaby was appointed Professor of Ornament and Design at the Royal College of Art, London, and in the same year Johnston began his part-time teaching of Lettering there. It was an entirely new concept for writing and lettering to form an integral part of art education. Johnston's classes soon became full and he had to devise methods of mass instruction. He began with class sheets which he wrote himself in hectograph ink for reproduction in the limited number of copies required. Later, he took to illustrating his lectures by remarkable blackboard demonstrations which were an inspiration to all who attended; this ephemeral teaching technique was recorded photographically by one of his students, Violet Hawkes, and thus saved for posterity.

In 1906 Johnston's first book, *Writing and Illuminating, and Lettering*, was published and remains in print today. Sydney Cockerell said of it:

Johnston's handbook is a masterpiece, immensely instructive and stimulating. And not only technically helpful, for the reader is conscious all the time of being brought in touch with a rare and

fine spirit. *Writing and Illuminating, and Lettering* won him disciples and followers not only in this country but in Germany, where he had a powerful advocate in one of his best pupils, Anna Simons, in America and even as far afield as Australia.

In 1909 a portfolio of *Manuscript and Inscription Letters* was published for schools and for craftsmen. These sample alphabets were based on Johnston's earlier class sheets and included plates by Eric Gill. In the 1920s his *Pepler*, or *Winchester Writing Sheets*, partly written by hand and partly typeset, were produced for his students. Today these have become valuable collectors' items.

COPY No. I. *After* WINCHESTER FORMAL WRITING about 975 A.D.

Et haec scribimus vobis ut gaudeatis, & gaudium vestrum sit plenum.

Et haec est annunciatio, quam audivimus ab eo, & annunciamus vobis : Quoniam Deus lux est, & tenebrae in eo non sunt ullae.

Note: This copy is written with a pen, not printed E.J. 26. August 1919 A.D.

Winchester MS. v. slightly modified.

Heavy Italics based on Winchester MS.

In order that a child may learn how to write well the teaching of handwriting should begin with the practice of a Formal Hand. This Manuscript is written with a BROAD-NIBBED PEN which makes the strokes thick or thin according to the direction in which it moves. The strokes are generally begun downwards or forwards & the letters are formed of several strokes (*the pen being lifted after each stroke*): thus *c* consists of *two* strokes, the first a long curve down, the second a short curve forward. The triangular 'heads' (as for *b* or *d*) are made by *three* strokes; 1st. a short thick curve down, 2nd. a short thin stroke up (*the nib for this stroke being placed on the beginning of the first and slid up to the right*), 3rd. the thick straight *stem* stroke of the letter itself down (*the pen for this stroke not being lifted*).

Broad-nibbed steel pens and Reeds may be used: Quill pens are very good but require special cutting. How to cut Quill and Reed pens may be learned from my Handbook "Writing & Illuminating, & Lettering" (*John Hogg, London:* 6s. 6d. *net*) besides how to make MS. Books and to write in colour. Edward Johnston: *Ditchling, Sussex.*

THIS SHEET IS PUBLISHED BY DOUGLAS PEPLER at HAMPSHIRE HOUSE HAMMERSMITH
1916 A.D.

Price Five Shillings

26

S. Luke iv. 16. 17. 18. 19. (R.V.). And he came to Nazareth where he had been brought up: & he entered, as his custom was, into the synagogue on the sabbath day, & stood up to read. And there was delivered unto him the book of the prophet Isaiah. And he opened the book, & found the place where it was written,

The Spirit of the Lord is upon me', Because he anointed me to preach good tidings to the poor : He hath sent me to proclaim release to the captives, And recovering of sight to the blind , To set at liberty them that are bruised, To proclaim the acceptable year of the Lord.

Johnston revealed his own mastery of calligraphy in his private commissions. He was sought after by public bodies and private patrons to make presentation addresses, rolls of honour, church service books, wedding gifts and the like. Notable among these early works were a Communion Service for a church in Hastings, a Coronation Address to Edward VII, Freedom Scrolls for the Livery Companies of the City of London and a magnificent Roll of Honour for the Borough of Keighley. *A Book of Sample Scripts*, written on vellum for Sydney Cockerell and completed in 1914, is now in the Victoria and Albert Museum.

It would be hard to exaggerate the importance of Johnston's influence as a teacher-designer upon letterforms in Britain and elsewhere in Europe, especially in Germany. Between the years 1910 and 1930 he designed initial letters and typefaces for Count Harry Kessler, founder of the Cranach Press in Weimar.

In 1915 he was commissioned by Frank Pick to design a special type for the use of the London Transport Services, the result being the well-known Johnston sans serif, a block-letter alphabet based on classical Roman proportions.

William Graily Hewitt, 1864–1952, was educated at Westminster and Trinity College, Cambridge. He was called to the Bar in 1889 but, finding no satisfaction in his profession, he turned to penmanship and the study of medieval manuscripts. On the advice of Sydney Cockerell he became a student at Johnston's evening classes at the Central School. He gained rapidly in proficiency and was put in charge of an additional class in 1901. A year later he took over Johnston's class at the Camberwell School of Art.

Above
Edward Johnston
And he came to Nazareth (St. Luke IV 16–19, RV). Vellum panel written out in vermilion ink as a late Christmas gift to his sister, Olof. 14 × 14.2 cm (5½″ × 5½″). February 1915
(By courtesy of Andrew Johnston.)

Opposite page
Edward Johnston
One of the four Winchester Formal Writing sheets published by Douglas Pepler. The first four lines written by Johnson in his Foundational Hand and the four lines below in a formal italic. Both scripts were developed after a study of 10th-century manuscripts in the British Museum. Lettering is in black, with typematter in red (including a wood block by Eric Gill). 11″ × 8½″ (28 × 21.5 cm). 1919
(By courtesy of the Crafts Study Centre, Bath.)

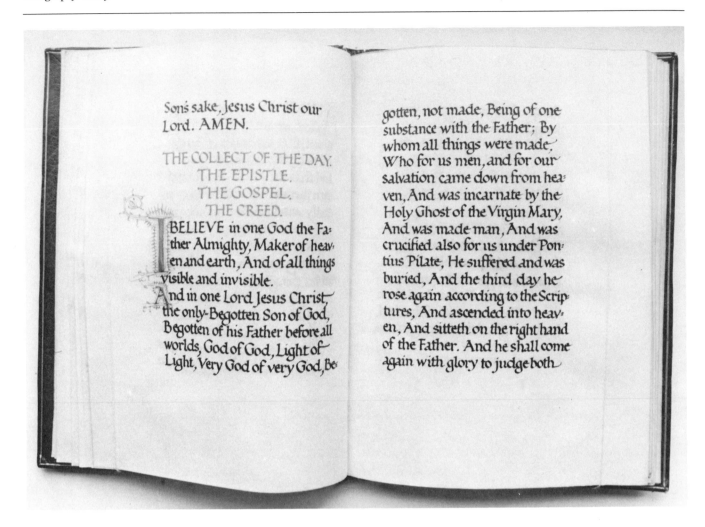

Graily Hewitt
The Communion Service. Written out in black ink on parchment, with capitals in vermilion. Initial letters in raised and burnished gold throughout, with fine-line ornament in blue or red. Slightly reduced. 1921
(By courtesy of Mrs Groucher.)

A series of six hectographed class instruction sheets, dated 1903, offers an interesting comparison with the methods of Johnston's other disciples: Anna Simons and Laurence Christie appear to have been content merely to copy Johnston's own class sheets, whilst Hewitt's are more distinctly original.[1]

Hewitt replaced Johnston at the Central School in 1912. His students included Alfred Fairbank, Dorothy Hutton, Vera Law, Madelyn Walker and Rosemary Ratcliffe, his successor in 1930.

Hewitt's greatest achievement was his recovery of the craft of laying and burnishing gold leaf. The illuminated pages of medieval manuscripts owe much of their magnificence to the brilliance of pure gold leaf, which may still retain its beauty and burnish after hundreds of years. When the art of formal writing declined, with the invention of printing, the allied crafts of illuminating and gilding manuscripts deteriorated also and the relevant skills were lost. With the revival of calligraphy in the twentieth century the opportunity for the use of burnished gold returned. Hewitt conducted experiments to find out the right composition of the gesso used under gold leaf as a raising preparation. The unsurpassed gilding in his manuscripts, some wholly written in gesso, then gilded and burnished, testify to the success of his preparations and to his skill. His methods are described in the appendix that he wrote for Johnston's *Writing and Illuminating, and Lettering*, and in his own book, *Lettering: for Students and Craftsmen*.

[1] Justin Howes: *A Handlist of the Calligraphy Collection*, Crafts Study Centre, Bath.

Hewitt admired the Humanist manuscripts of the fifteenth century and particularly those of Antonio Sinibaldi and Johannes Andreas de Colonia. In his own work, he developed a style of illumination which elaborated on the initial letter, itself often of burnished gold. He used details of trees and shrubs for decoration and texture – the oak with gilded acorns, the chestnut, beech, rose and ivy – to these he added a filigree of flower forms such as speedwell, clover, pimpernel and bryony, enlivened with butterflies and birds. This manner of illumination was exquisitely carried out to his designs by Madelyn Walker, Ida Henstock and other scribes. Hewitt and his assistants came close to the medieval concept of a scriptorium or team of craftsmen, each contributing his skill to the making and decorating of fine manuscripts so that the product was the fruit of close collaboration.

In the early years of the twentieth century Edward Johnston and Graily alone had sufficient knowledge of calligraphy to teach the subject. When the Birmingham College of Art wanted to begin a class, Ernest Treglown was sent to London especially to study with Johnston. Leicester College of Art was the next to have a lettering class and eventually the subject became an integral part of the curriculum in art schools throughout the country.

During the 1930s a number of Johnston's students who became freelance calligraphers were also practising teachers: Daisy Alcock; Margaret Alexander; Mervyn Oliver; Dorothy Mahoney, who was appointed to carry on Johnston's class at the Royal College of Art when he retired in 1939; Thomas Swindlehurst and Irene Wellington.

In considering the Revival we should listen to Sydney Cockerell, one of the most influential minds of the period. He wrote in 1914:[1]

> In recent years England has seen a notable revival of Calligraphy, that is to say of beautiful and formal handwriting. This revival has already had echoes on the continent and in America and bids fair eventually not only to lead to the wide production of highly finished manuscripts for those who can afford them, but also to influence for good, through school-teachers and improved copybooks in many countries, the types of handwriting and lettering now in general vogue. That these types sadly need artistic revision is everywhere admitted...
>
> From this (Johnston's) class, which meets under his guidance, or from offshoots of it controlled by his pupils, nearly all the English calligraphers of the present day have sprung.

In 1906 Johnston issued a handbook entitled *Writing and Illuminating, and Lettering*. It is crammed with practical instructions, lucidly arranged and profusely illustrated, and has greatly aided the spread of the movement at a distance.

Experience has shown that with the help of this admirable handbook (supposing the personal guidance of a skilled teacher to be unobtainable) anyone combining patience and intelligence with reasonable aptitude can cultivate a legible and beautiful handwriting. But it has also shown that, whereas it is not difficult to reach a certain level of proficiency, the majority of pupils stop at this point, and only a comparatively small number attain to what may be called a professional standard, one involving the exercise of originality, understanding and resource, as well as general accomplishment. These qualities are all important, for while there are countless wrong ways, there are also fortunately as many right ways of forming every letter of the alphabet.

[1] S C Cockerell: *Modern English Calligraphy and Illumination*, Edward Johnston loan collection and archive, Crafts Study Centre, Bath. By courtesy of Andrew Johnston.

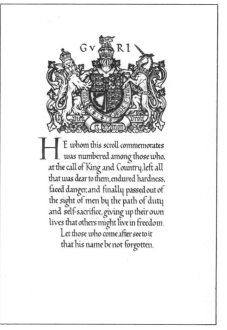

Graily Hewitt
Memorial scroll presented to the next of kin of the fallen in the First World War. Designed by **Graily Hewitt**, Noel Rooke, H Laurence Christie and G Kruger Gray. Engraved on wood by Noel Rooke and printed with the Royal Arms in full colour. The name and title of the deceased handwritten in colour below the citation. 28.8 × 19.3 cm (11¼″ × 7½″). 1917 (By courtesy of the Crafts Study Centre, Bath.)

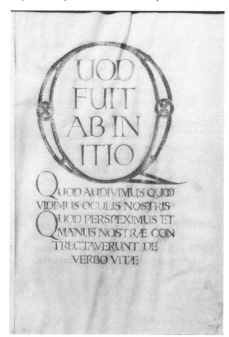

Ernest Treglown
Page from a manuscript book. Written on vellum with capitals in gold on the recto page. 8½″ × 11½″ (21.5 × 29 cm). (By courtesy of Charles Thomas.)

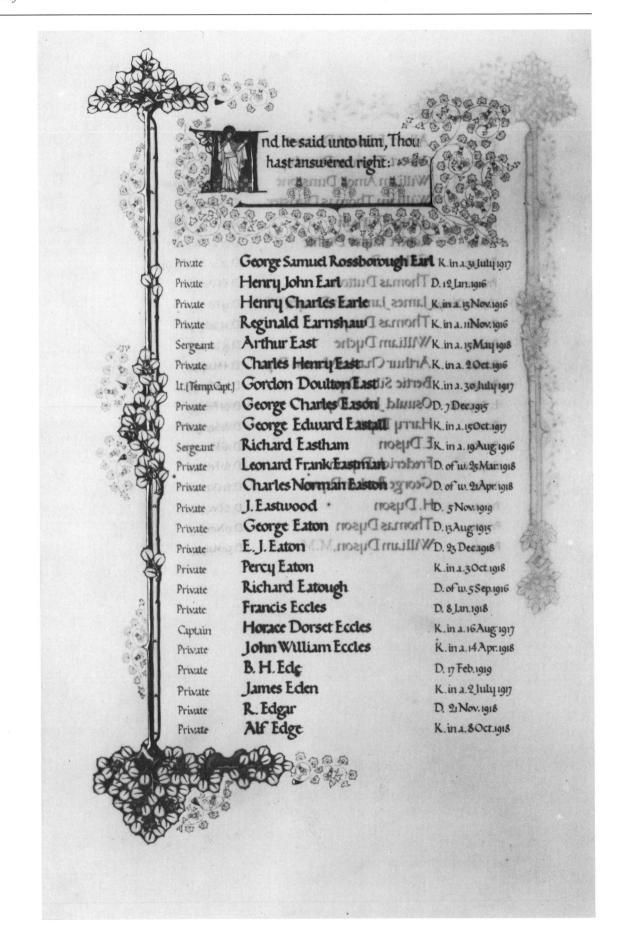

And he said unto him, Thou hast answered right:

Private	George Samuel Rossborough Earl	K. in a. 31 July 1917
Private	Henry John Earl	D. 12 Jan. 1916
Private	Henry Charles Earle	K. in a. 15 Nov. 1916
Private	Reginald Earnshaw	K. in a. 11 Nov. 1916
Sergeant	Arthur East	K. in a. 15 May 1918
Private	Charles Henry East	K. in a. 2 Oct. 1916
Lt. (Temp. Capt.)	Gordon Doulton East	K. in a. 30 July 1917
Private	George Charles Eason	D. 7 Dec. 1915
Private	George Edward Eastall	K. in a. 15 Oct. 1917
Sergeant	Richard Eastham	K. in a. 19 Aug. 1916
Private	Leonard Frank Eastman	D. of w. 25 Mar. 1918
Private	Charles Norman Easton	D. of w. 21 Apr. 1918
Private	J. Eastwood	D. 5 Nov. 1919
Private	George Eaton	D. 13 Aug. 1915
Private	E. J. Eaton	D. 23 Dec. 1918
Private	Percy Eaton	K. in a. 3 Oct. 1918
Private	Richard Eatough	D. of w. 5 Sep. 1916
Private	Francis Eccles	D. 8 Jan. 1918
Captain	Horace Dorset Eccles	K. in a. 16 Aug. 1917
Private	John William Eccles	K. in a. 14 Apr. 1918
Private	B. H. Edc	D. 17 Feb. 1919
Private	James Eden	K. in a. 2 July 1917
Private	R. Edgar	D. 21 Nov. 1918
Private	Alf Edge	K. in a. 8 Oct. 1918

These exhibitions gave contemporary calligraphy an opportunity to come before a much wider public and during this period the reputation of the SSI was climbing steadily. Even through the difficulties of the Second World War the Society held together, the scattered members kept in touch through a newsletter despatched worldwide from London.

In the years following the 1939–45 War, many Rolls of Honour for the Services were written and illuminated by members of the SSI. In Westminster Abbey, for example, there are five magnificent memorial books on vellum, and across the country almost every cathedral, college chapel and many churches display their own. The Royal Air Force Book of Remembrance and the United States Roll, dedicated at St Clement Dane's, London, between 1962 and 1964, were major undertakings. The recording of 150,963 names was carried out by thirteen scribes in eleven volumes under the design and direction of Alfred Fairbank. The emphasis on memorial books and panels continued to colour the public's conception of calligraphy at this time.

As in the years preceding the war, manuscripts for ceremonial occasions occupied calligraphers: Loyal Addresses to the Sovereign; Royal Charters; Patents of Nobility; presentation addresses for public institutions, for the expression of honour and appreciation; Freedom scrolls and heraldry for City Livery Companies. Manuscripts for private collectors were commissioned – books of poetry and fine prose, family trees and decorative maps – these are all unique works serving a purpose where the use of type is inappropriate. The bread-and-butter work such as the writing of names on certificates, diplomas, and formal invitations, continues unobtrusively to this day.

As a professional body the SSI has demanded rigorous standards for election to craft membership. It became one of the five major craft societies that formed the British Crafts Centre, which opened in 1951, with the help of a small government grant, under the chairmanship of John Farleigh, the wood engraver. This Centre gave the whole of the Crafts Movement a new momentum, for there was for the first time a worthy exhibition centre in London's West End. The SSI held a series of notable exhibitions there in 1951, 1956, and 1961; then in 1966 at the National Book League in London. Calligraphy had established itself and the Society and its aims became widely known.

Lay Membership of the SSI, instituted in 1952, resulted from the public response to these developments. It is open to all those who, by their interest and support, wish to forward the aims of the Society. While Craft Members (now Fellows) have averaged around 65 to 70 in number for many years, Lay Members today (1987) are approximately 2000. The enthusiastic support of the lay members has played a large part in the prosperity of the Society and today in the running of it.

Also in 1952, the SSI, with Alfred Fairbank as its newly elected President, founded the Society for Italic Handwriting, in response to the enormous public interest in learning to write the italic hand.

The Annual Open Meeting of the SSI, which attracts a large and enthusiastic audience, has over the years been addressed by many distinguished speakers, not only on aspects of calligraphy and illumination, but on related subjects such as palaeography, heraldry, genealogy and the chemistry of pigments. Over the past thirty years many of the eminent speakers at the annual meetings have been elected Honorary Members, among them: Sydney Cockerell, Eric Millar, James Wardrop, Walter Oakeshott and Julian Brown.

Honorary Membership was instituted by the SSI to give recognition to those who have assisted in the advancement of the craft or had been of

The exhibition included five Freedom Scrolls made for City Livery Companies by Edward Johnston, and numerous presentation addresses executed by Graily Hewitt and Ida Henstock, Laurence Christie, Daisy Alcock, Ernest Treglown, Mervyn Oliver and others.

With this flowering of the calligraphic movement in Britain, exhibitions were sent to the USA in 1930 and 1938, at the invitation of the American Institute of Graphic Arts. The second was shown in New York, Boston and Chicago, as well as the Universities of Yale and Pittsburgh. In 1931 work was sent to the Salon International du Livre d'Art at the Petit Palais des Beaux-Arts in Paris, and in 1932 calligraphy was shown in Copenhagen at the British Industrial Art Exhibition.

An exhibition of the work of members held at the Architectural Association in 1936 created great interest and attracted a large number of visitors. John M Holmes in a brief review wrote: 'The varied expression and individuality of script writing is something to wonder at considering the purifying effect of standardisation accomplished by Edward Johnston in 1906. The fascination of the craft is in its freedom of expression within clearly defined laws. It is refreshing to realise that hand work can flourish so excitingly in a mechanised world.' He mentioned several exhibits he considered of major importance, among them: Johnston's *Forty lines of a Greek Uncial MS.*; the glittering pattern of a *Sheet from Eclogues and Georgics* from Virgil, written and gilded by Alfred Fairbank and illuminated by Louise Powell; a *Medieval Carol* transcribed by Rosemary Ratcliffe and *The Diary of an English Holiday* by Irene Sutton (Wellington). 'Calligraphy is here wedded to illustration and the pen indulges in witty comment and seems to share the enjoyment of the writer and the reader.'

Alfred Fairbank

An opening from *Eclogues and Georgics* by Virgil. Writing and gilding by Alfred Fairbank, illuminating by Louise Powell. Page size 12″ × 8″ (30.5 × 20.5 cm). 1932 to 1939
(By courtesy of Simon Hornby.)

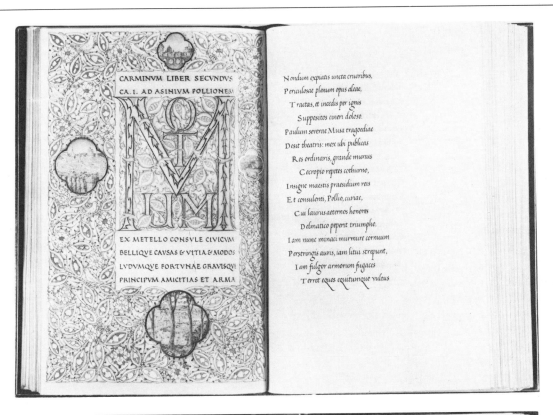

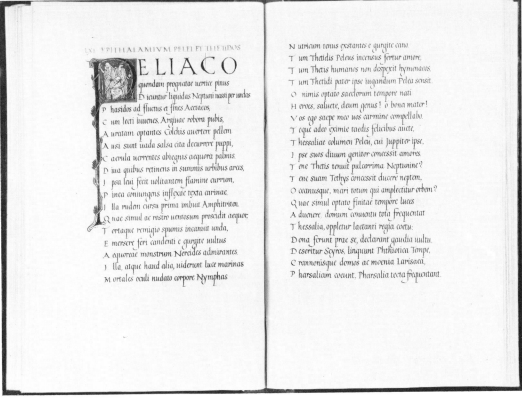

Above
Alfred Fairbank
Page from *Odes and Epodes* by Horace.
Writing and gilding by Alfred Fairbank,
illuminating by Louise Powell. Page size
9″ × 6″ (23 × 15 cm). 1927 to 1931
(By courtesy of Simon Hornby.)

Below
Madelyn Walker
An opening from a manuscript copy of
Catullus. Written out in an italic hand in
black, red and green and gilded.
Illumination by Joan Kingsford. 8″ × 5½″
(20.5 × 14 cm). 1929

The Society of Scribes and Illuminators

It was in 1921 – shortly after the end of the Great War – that the Society of Scribes and Illuminators was founded. The idea came initially from Graily Hewitt and Laurence Christie, who had been students of Edward Johnston and were teaching writing classes at the Central School of Arts and Crafts. At first the Society was composed mainly of those associated with the Central School. The original Constitution was definite, its purpose was defined as:

> the advancement of the crafts of Writing and Illumination by the practice of these for themselves alone… that the aim of the Society should be directed towards the production of books and documents wholly hand made; regarding other application of the work as subordinate, but not excluding it.

Although with hindsight this appears a restricting aim for the new Society it was in keeping with the ethos of the times.

The Society's first public exhibition was held in 1922 in the Brook Street Gallery, London, at which 106 works were shown by 31 members. In the early years it was easy to join but it soon became clear that much more than enthusiasm for the craft must be shown in manuscripts that could be accepted by a selection committee. The standard of work required for membership rose steadily and the reputation of the Society with it.

In 1924 small research groups of members were set up to study particular problems and techniques, such as the writing surfaces of skins, the quality of pigments, the preparation of inks and methods of gilding, as well as heraldic design in manuscripts and styles of cursive handwriting. The Society holds the unique Record Book in which the results of experiments and discussions were recorded. Perhaps the cursive handwriting group under the direction of Alfred Fairbank had the most far-reaching effect in later years; but the findings of all these groups had an influence on the first *Calligrapher's Handbook* when it was being compiled in the 1950s.

War memorials mainly in book form were being commissioned to record the names of those fallen in the 1914–18 war. We illustrate the Roll of the Royal Army Medical Corps, now in Westminster Abbey, which is the work of Graily Hewitt and his assistants. Letters Patent of Nobility and other important documents for the Crown Office and Home Office were enscribed by Hewitt and other members of the SSI, also Church Service books and presentation addresses – unique works particularly appropriate for formal penmanship, heraldic decoration and gilding on vellum, each being made for one ceremonial occasion and for posterity.

Superb manuscript books on vellum were made for outstanding patrons, notably St John Hornby of the Ashendene Press and Arnold Danvers Power. The Horace and the Virgil manuscripts transcribed and gilded by Alfred Fairbank for St John Hornby were illuminated by Louise Powell. His *Ecclesiasticus* written out for Arnold Power is now in the Fitzwilliam Museum, Cambridge. Another fruitful collaboration was between Madelyn Walker, who transcribed and gilded the Catullus for St John Hornby, and Joan Kingsford who illuminated the manuscript. The *Book of Proverbs* written out and illuminated by Margaret Alexander for Arnold Power is now in the British Library.

In 1931 the SSI, with the co-operation of the Victoria and Albert Museum, arranged an exhibition of Three Centuries of Illuminated Addresses, Diplomas and Honorary Freedom Scrolls. The presentation of these manuscripts to persons of distinction is a custom with a long tradition in our national life. Certain City Companies admitted Honorary Freemen as early as the fourteenth century.

Opposite page
Graily Hewitt
From the Memorial Roll of the Royal Army Medical Corps. The work of **Graily Hewitt** and his assistants: Horace Higgins, Madelyn Walker, Florence Raymond, Ida Henstock, Vera Peacock and Rico Capey. The writing, after the style of Humanist scribes of the 15th century, is mainly the work of Horace Higgins. The burnished gold initial at the top of the page contains a miniature illustrating the parable of the Good Samaritan.
(In the Chapter House, Westminster Abbey. By courtesy of the Director General, Army Medical Services.)

31

service to the Society. The first such members to be elected in 1922 were Edward Johnston, Oswald Barron* and W R Lethaby.

While the SSI has led the calligraphic movement in Britain since the 1920s there have always been fine scribes and lettering craftsmen with no wish or reason to submit work for election to craft membership and some of their manuscripts are illustrated in this book.

*The distinguished herald and writer of a column in the London Evening News over the signature of 'The Londoner'.

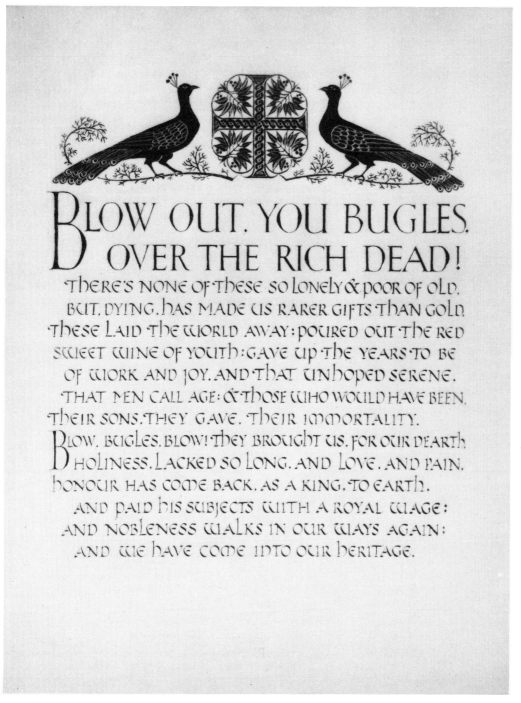

Irene Base
Sonnet by Rupert Brooke. Written out on vellum and illuminated entirely in raised and burnished gold. 24″ × 20″ (61 × 51 cm). 1944
(In the possession of Marylyn Bacon.)

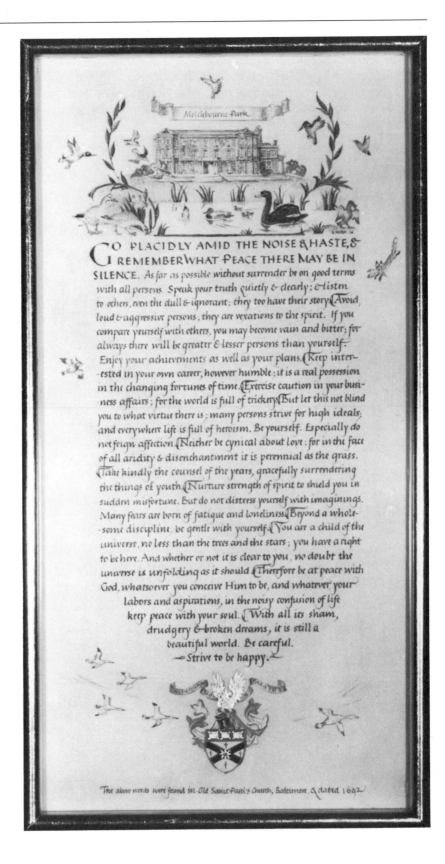

Dorothy Hutton
Go placidly...: words found in Old St Paul's
Church, Baltimore, dated 1692. Framed
presentation gift. Writing in black, with
capitals, miniature of Melchbourne Park
and heraldic motifs in colour and gold.
Reduced by ⅓. 1974

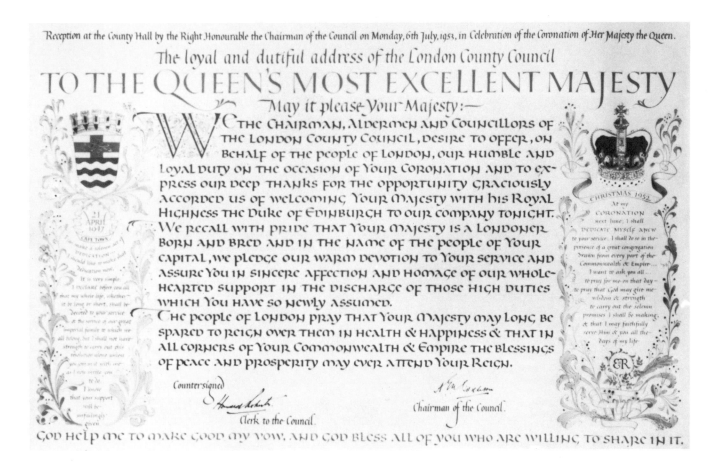

Above

Irene Wellington

Coronation Address to HM Queen
Elizabeth II from the London County
Council. Vellum scroll. Capitals in red
between two lines of blue writing, with the
main text in black uncials. Initial W in blue
outline decorated with gold. The dedication
speeches (flanking the main text) in pale
brown with matt gold leaves and burnished
gold 21.5 × 35.5 cm (8½″ × 14″). 1953

Left

Margaret Alexander

Certificate of Honorary Membership of the
British Medical Association for H R H the
Duke of Edinburgh. Written on vellum in
red, blue and black, with burnished gold,
1954.

Thomas W Swindlehurst
Freedom Scroll presented to Lord
Mackintosh of Halifax by the Council of the
County Borough of Halifax, 29 June 1954.
Written, painted and gilded on vellum.
Leather-bound scroll case, with arms and
lettering in gold. Scroll size 24″ × 8″
(61 × 20.5 cm).

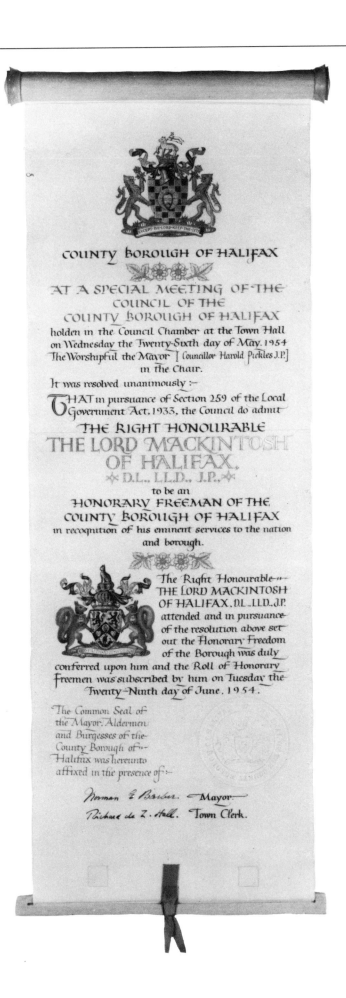

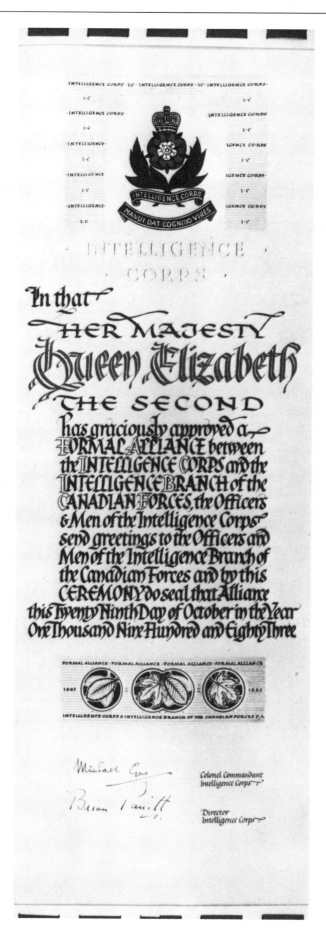

Left

Maisie Sherley
Scroll for the Intelligence Corps. Written
with turkey quills on classic vellum, in red,
black and green, with raised and matt gold.
23″ × 8″ (58.5 × 20.5 cm). 1983

Below

William M Gardner
Record of the names of wild flowers
growing in the lanes behind the scribe's
home in Kent. English and Latin written
across inlaid coloured papers which 'move'
from winter/white through grey, pale green
and dark green, to autumn tints and white
again. 1974

"He was one of the few really great men of our time": that is what Francis Meynell said of Johnston. Now, that's a stiff one; but it's true. I will start by telling you about him as I saw him in 1900, when he was nearly twenty-eight, making his notable discoveries. His discoveries were about letters of the alphabet, & the shapes of the letters; the letters we use every day in reading, writing, printing; those tools we all use, sometimes without much understanding; sometimes misusing them. Johnston understood them better than any man since we started this game of reading & writing thousands of years ago. He made them and he used them better than any man for centuries.

Quotation from "Written Beauty" by Noel Rooke: Written out for H Band & Co. by M.C. Oliver. 11·8·48.

Mervyn C Oliver
'He was one of the few really great men': words from *Written Beauty* by Noel Rooke.
Written in the Foundational Hand with black ink on manuscript vellum. For Henry
Band & Co., the vellum manufacturers. 1948

TO THE QUEEN'S
MOST EXCELLENT MAJESTY

May it please Your Majesty

WE, Your Majesty's faithful subjects, THE PRESIDENT, COUNCIL AND MEMBERS OF THE CHARTERED INSURANCE INSTITUTE, with our humble duty beg leave to offer to Your Majesty on the occasion of the Diamond Jubilee of the Institute, an assurance of our constant loyalty and devotion to Your Majesty's Crown and Person.

WE recall with pride that our Institute, founded in 1897, was honoured in 1912 by a Royal Charter granted by Your Majesty's illustrious Grandfather, King George V, and that we were further honoured in 1934 when He, in company with Your Majesty's Grandmother, Queen Mary, consented to open our new Hall erected in the City of London during that year.

WE desire also to record with deep and abiding gratitude the further mark of Royal Favour conferred upon us in 1935 by the grant of His Royal Patronage by King George V, an honour continued by His Majesty's Successors and most graciously confirmed by Your Majesty on Your accession to the Throne in 1952.

THE Institute has for one of its principal objects the education of its members in the principles and practice of insurance. It seeks thus to promote the efficiency with which the operations of insurance are conducted, being ever mindful of the fundamental principle upon which insurance is based, whereby the misfortunes of the few are lightened by the contributions of the many.

THE educational activities of the Institute, while centred in the United Kingdom, are pursued in all parts of the Commonwealth, as well as in many other countries of the world. By thus spreading the knowledge of insurance on an international basis, the Institute endeavours to play its part in promoting that peace between all peoples which we know is so close to Your Majesty's heart.

IN looking forward to the future under the shield of Your Majesty's gracious favour, we hope ever to maintain the ideals inherited from our forbears, and so to conduct our business of insurance as to mitigate throughout the world the effects of misfortune, thereby promoting the security and welfare of mankind in general and, not least among them, of Your Majesty's subjects.

Given under the common seal of the Institute this twenty-seventh day of June nineteen hundred and fifty-seven.

President

Secretary

Deputy President

Top
Thomas W Swindlehurst
Book plate.

Bottom
Reynolds Stone
Book plate for University Library, Liverpool.
4″ × 2¾″ (10 × 7 cm). 1948

Margaret Alexander
Illuminated Address to HM the Queen from
the Chartered Insurance Institute. Vellum
scroll. 27″ × 16″ (68.5 × 40.5 cm). 1957

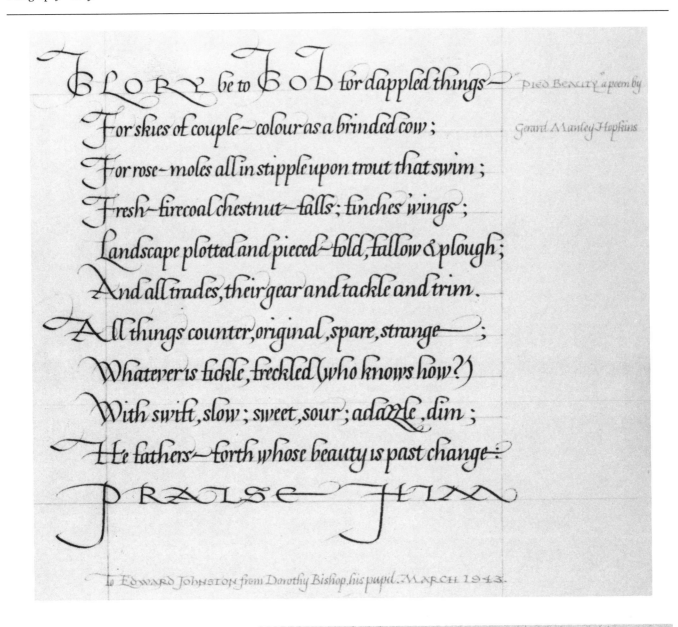

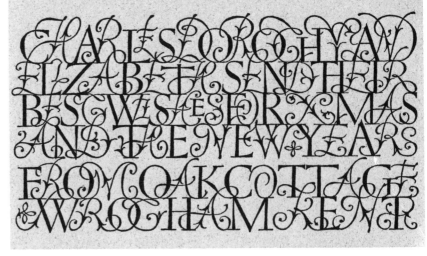

Above
Dorothy Mahoney
Pied Beauty by Gerard Manley Hopkins.
Written out in black ink on vellum. A gift
from the calligrapher to Edward Johnston.
23.4 × 21.7 cm (9¼" × 8½"). 1943
(By courtesy of the Crafts Study Centre,
Bath.)

Right
Dorothy Mahoney
Christmas wishes. Black on pink. 4¾" × 7¼"
(12 × 18.5 cm).

Left
Eric Gill
Two wood-engraved book plates.

Below
Irene Wellington
Good Friday headings for the Radio Times.
Tape width 3.3 cm (1¼″) × length 21.5 cm
(8½″). 1952

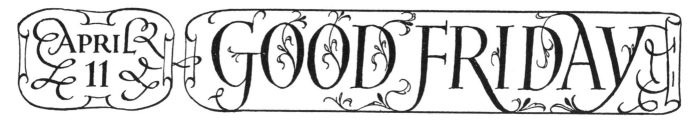

Left
Reynolds Stone
Engraving. 5.1 × 9.6 cm (2″ × 3¾″).

Reynolds Stone
Commemorative mug designs to mark
Francis Meynell's 70th birthday.
7.8 × 7.4 cm (3″ square). 1961

His Royal Highness
Prince George Edward Alexander Edmund,
DUKE OF KENT

Born 20th December, 1902.
Knight of the Most Noble Order of the Garter,
Knight of the Most Ancient and Most Noble
Order of the Thistle, Knight Grand Cross of

Above right
Ida Henstock
Page from the House of Lords Roll of
Honour, 1939–1945

Right
Mervyn C Oliver
Church notice. Written on vellum. 1935
(Victoria and Albert Museum, Circ. 347–
1935, press mark PC. 1/8, no. 6.)

This Church is the House of
God tabernacling amongst
men. Enter therefore and
adore him or else enter not

Above

Maisie Sherley

Map of Ambleside. Written and drawn with
crow and turkey quills on classic vellum, in
sepia and vermilion, with tints of blue,
yellow and green. $25\frac{1}{2}'' \times 32''$ (65×81 cm).
1944

Left

Leo Wyatt

Map of Epsom designed and wood
engraved for Beatrice L Warde. $3\frac{1}{2}'' \times 5\frac{1}{2}''$
(9×14 cm).

Cursive handwriting – the Italic resurgence

'One of the most practical benefits to arise from the study of calligraphy would be an improvement in ordinary present-day handwriting – a thing much to be desired' – so thought Edward Johnston as early as 1906.

After the First World War detailed research into Humanist scripts by palaeographers, typographers and calligraphers, of the calibre of B L Ullmann, Stanley Morison, James Wardrop and Alfred Fairbank, led to an appreciation of italic and the possible revival of italic handwriting.

Alfred Fairbank, a student of Graily Hewitt and Laurence Christie, was initially attracted to formal book hands, but as early as 1923 he became interested in italic script and this led to the publication of his *Woodside Writing Cards* in 1932, and his *Barking Writing Cards* in 1935, later known as *Dryad Writing Cards*. These exemplars illustrate a model cursive hand which allows joins. In 1932 his book *Handwriting Manual* came out, the forerunner of a wave of books on italic and still the most outstanding and influential. (His well-known *Book of Scripts* became a Penguin bestseller in 1949.)

In 1952 Alfred Fairbank, then President of the SSI, encouraged the formation of the Society for Italic Handwriting. This aimed to focus public interest on reforming slipshod handwriting in general and the adoption of an italic script in particular. The new Society rapidly gained international support and is linked today by the *Journal*, edited for twenty-four years by A S Osley, which not only keeps the membership in touch with developments in modern italic handwriting, but also encourages research into the origins of Renaissance scripts.

Alfred Fairbank was editor and calligrapher for the *Beacon Writing Books*, a system for teaching italic in schools. There has been something of a reaction against the ardent advocacy of italic handwriting due in part to unfounded prejudice, but the main hindrance is lack of training for teachers.

The distinction should be stressed between formal italic exemplified by the Writing Masters of the Renaissance, which is a beautiful and elegant book hand, and the free cursive italic, a legible and rapid hand which offers a graceful alternative to unconsidered handwriting.

Many children and adults find the genuine pleasure of craftsmanship in mastering this hand for their everyday use. Many calligraphers who have had a particular interest in the improvement of handwriting include: Irene Wellington whose *Copybooks* are especially popular in America, and George Thompson and Tom Gourdie, students of Irene Wellington at Edinburgh College of Art, who have both promoted better handwriting through their own manuals, and the latter through his worldwide travels. Tom Barnard, who has had wide experience of handwriting in schools, advocates the teaching of italic letter shapes to infant classes, using single-line tools, so as to lay a foundation for the further development of cursive writing.

Berthold Wolpe
Book jacket for Faber and Faber, publishers.

Left
Heather Child
Illuminated address presented to the
Marquess of Cholmondeley by the Society
of Italic Handwriting. Written and gilded on
vellum. Hand-bound in calfskin with
vellum-coloured ribbon ties.

Below
William Morris
Page of trial writing on vellum. In a letter to
Major Abbey, 24 November 1962, Alfred
Fairbank wrote, 'That leaf of Wm. Morris
establishes him at the very beginning of the
movement for Italic handwriting, since it
showed he was studying Arrighi's *Il Modo*
and it therefore has historical importance.'
c 1870

Left
Irene Wellington
Title page for a manuscript book recording
the names of the winners of the
Cholmondeley Handwriting Competition
(between Eton, Harrow and Winchester).
Writing on vellum in black and red, with
the arms in full colour and gold. Page size
36 × 26 cm (14″ × 10″). 1950 (By courtesy
of the Society of Italic Handwriting.)

More recent developments in calligraphy

The middle years of the century saw a revival of the crafts generally in Britain, but one in which calligraphy did not play a full part. In the 1950s when the reorganisation and expansion of the Art Schools took place, calligraphy was dropped from the syllabus as being irrelevant and having no useful role in industry, ironically at a time of great public interest in the craft and demand for tuition. This has had a negative effect on the present scene, for the current shortage of teachers of quality stems from this decision. With a few exceptions, calligraphy has not been taught in Art Schools since the mid-1960s – it may occasionally feature in foundational courses for Graphic Design.

Nevertheless there are many scribes today, professionals and amateurs, who find great satisfaction in making unique calligraphic manuscripts, often on vellum, gilded and illuminated where appropriate, although they may have no wish to design for reproduction and do so reluctantly. With others, graphics is a major part of their work and their teaching. Some versatile calligraphers are equally at home with chisel or graver in their hand, as with the broad pen or brush.

The establishment of the Government-funded Crafts Council in 1971 produced financial support for the artist/craftsman through grants and bursaries, and brought to the development of the crafts generally, publicity, prestige and public encouragement.

In 1972 the exhibition of Edward Johnston's work at the Royal College of Art, London, celebrated his centenary and surprised and intrigued a younger generation of students, as did the six lectures on aspects of calligraphy held at the Victoria and Albert Museum at the same time. Two further collections of Johnston's work have been published since, the long-awaited *Formal Penmanship* in 1971 and *Lessons in Formal Writing* in 1985, and have renewed interest in his achievement.

In the 1970s Donald Jackson visited centres of calligraphy in the U.S.A., including Chicago, New York and San Francisco, rekindling a lively interest in the practice of the craft. The resulting enthusiasm generated the rapid growth of more than a hundred societies with ensuing demand for tuition. Other calligraphers were invited to the States, among them Ieuan Rees, Peter Halliday, David Howells, Ann Hechle, Alison Urwick, Stan Knight, Pat Russell and John Woodcock – to give workshops and lectures and stimulate a two-way exchange of views. A further result was a proliferation of calligraphy books, copybooks, how-to-do-it manuals and illustrated anthologies, on both sides of the Atlantic, which the public continues to buy.

The past two decades have been a period of marked change. A movement has taken place which has freed the scribe from the narrower tradition of formal penmanship with its emphasis on precision, legibility and symmetry to a world of spontaneity and experiment where self-expression, mood, texture, colour and abstract use of space are used to express the meaning of words. The 'calligraphy: art or craft?' debate will continue – there is no limit to the inventiveness possible in the *art* of calligraphy. Successful exhibitions with large attendances bring about the desire to do work that looks well in such settings and attracts publicity. This is perhaps an originating factor among others for the so-called expressive calligraphy movement today. Calligraphy is essentially an art of communication and the fine communication of ideas always remains a satisfying purpose – we narrow our horizons if we substitute decoration for communication.

David Howells
Book plate. Printed black on gold paper.
3″ × 3¼″ (7.5 × 8 cm). 1986

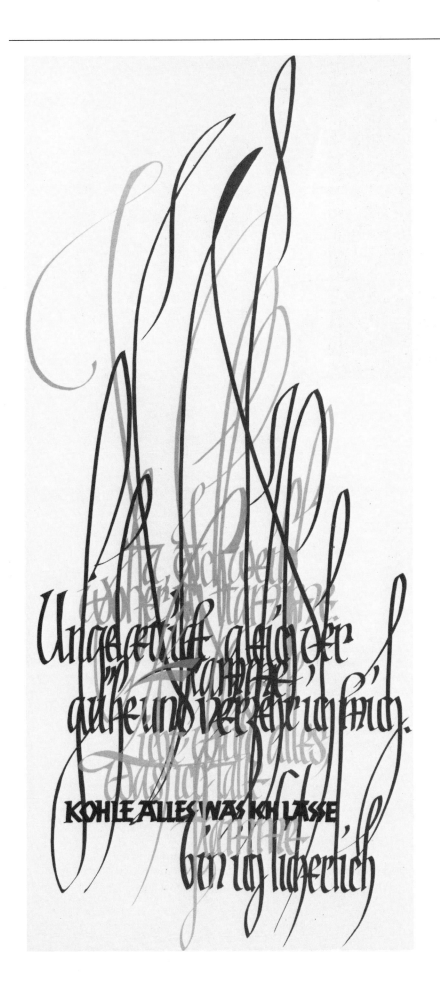

Hella Basu
Ecce Homo by Nietzsche. Written in two
colours on white. Printed in a limited
edition. 25″ (63.5 cm). high. 1974

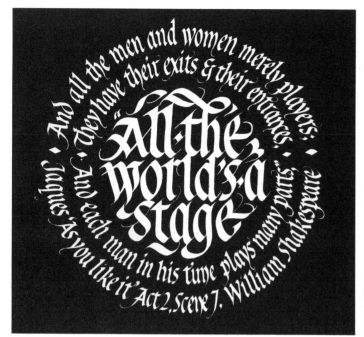

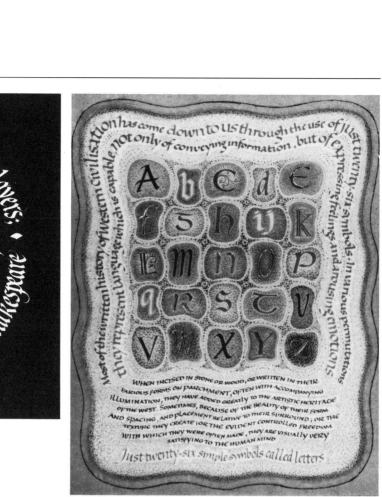

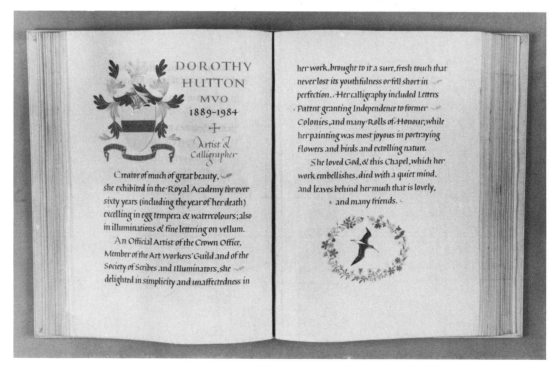

Top left
Ieuan Rees
Quotation. Lettering on browny-grey Ingres paper, with the centre off-white and the surrounding area milky-green with gold diamonds. Diameter $7\frac{1}{2}''$ (19 cm).

Top right
Sam Somerville
Twenty-six symbols. Written and drawn on calfskin vellum with stick ink and watercolour. Colour of support shows through stretched vellum. Various types of gilding. 15 × 12 cm ($5\frac{3}{4}'' \times 4\frac{3}{4}''$). 1986

Below
Joan Pilsbury
Memorial pages to Dorothy Hutton in the *Savoy Chapel Memorial Book.* Written on vellum with stick ink, with heraldry in full colour and burnished gold. Double-page size 14″ × $19\frac{1}{2}''$ (36 × 50 cm). 1985

David Williams
Menu. Written with quills on copier paper with stick ink. One of 600 printed in black and red and presented in the form of a scroll tied with ribbon. 20″ × 11″ (51 × 28 cm). 1985

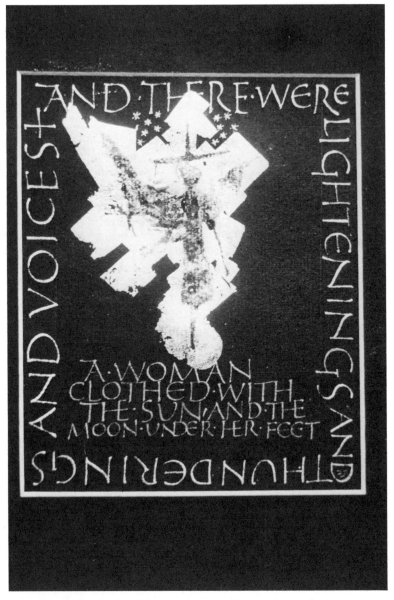

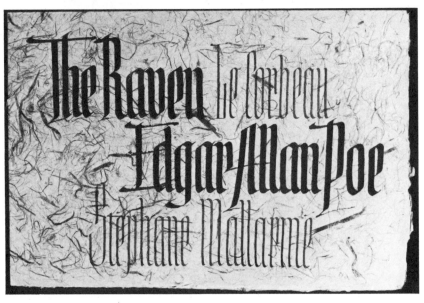

Above

Sam Somerville

Saturn. Prepared on dyed calfskin vellum. Toning produced by scraping and watercolour stippling. Burnished palladium leaf and flat gold leaf. 22 × 13 cm (8½″ × 5″). 1985

Above right

Donald Jackson

A Woman clothed with the Sun and the Moon under her Feet. Matt and burnished gold leaf on paper. 8″ × 5½″ (20.5 × 14 cm).

Right

Pat Russell

Title page for *The Raven* by Edgar Allan Poe (with a French translation by Mallarmé), a manuscript book written on highly textured Japanese paper (mustard colour) with purple/brown gouache for the English and blue/slate gouache for the French. 30 × 46 cm (11¾″ × 18″). 1965

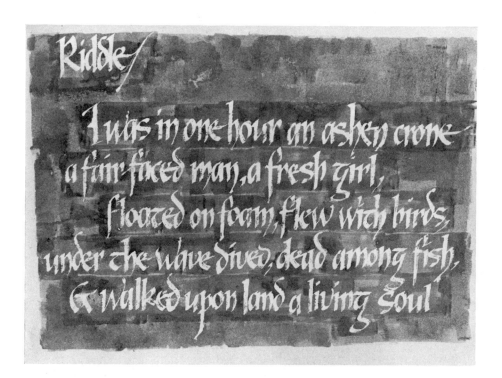

Left
John Woodcock
Riddle. Brush-drawn letters, gouache
resist, yellow inks on David Cox
watercolour paper. $19\frac{5}{8}'' \times 27\frac{3}{8}''$
(50×70 cm). 1968

Below
Lindsay Castell
The Oak Tree and the Reed. Green and
brown gouache on Dutch repair
paper. $14\frac{1}{2}'' \times 23''$ (37×58.5 cm).
1984

Riddle

I was in one hour an ashen crone
a fair faced man, a fresh girl,
floated on foam, flew with birds,
under the wave dived, dead among fish,
& walked upon land a living soul

ONE DAY
THE OAK TREE
SAID TO
THE REED

FABLE DE LA FONTAINE

You have every reason to blame nature. To you even a wren
is a heavy burden, and the slightest breath of air that happens
to ripple the surface of the water forces you to bow your head.

Whereas, like the high mountain,
I not only give shade from the sun, but resist the stormy blast.
To you every wind is a gale, to me it's only a gentle breeze.

If only you grew beneath the shelter of my branches
you wouldn't suffer so much. I would protect you from the tempest.

But you often take root on the banks of the kingdoms of the wind.
I think nature has treated you unjustly.'

'Your pity', REPLIED THE SLENDER PLANT,
springs from your natural goodness. But don't worry. For me the winds are less formidable than they are for you.
I bend and don't break. So far you have resisted their furious gusts without breaking, but let us see what happens.'

AS THESE WORDS WERE SPOKEN, THERE RUSHED UPON THEM FROM THE EDGE OF THE HORIZON
THE MOST TERRIFIC GALE THAT HAD EVER BLOWN FROM THE NORTH.
THE OAK TREE STOOD FIRM; THE REED BENT DOUBLE. THE WIND BLEW MORE FIERCELY STILL,
UNTIL WITH ITS TERRIBLE STRENGTH IT UPROOTED THE TREE WHOSE BRANCHES REACHED UP
TO HEAVEN AND WHOSE ROOTS WERE AMONG THE GRAVES OF THE DEAD.

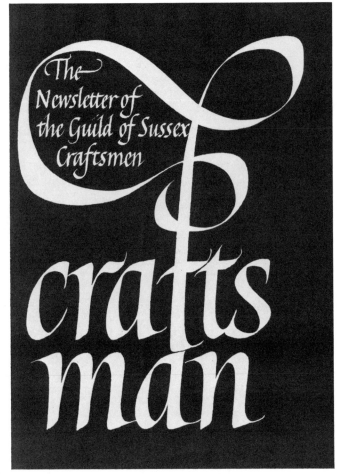

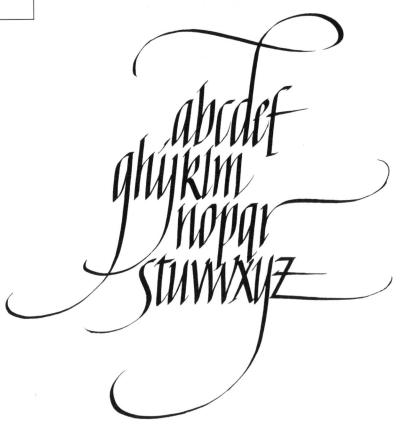

Above
John Shyvers
Greeting card. Written with a quill and
stick ink on handmade paper. 6″ × 4″
(15 × 10 cm). 1985

Above right
Michael Renton
Cover design for a newsletter. 8½″ × 6″
(21.5 × 15 cm). 1985

Right
Gaynor Goffe
Alphabet written with a steel pen. 1986

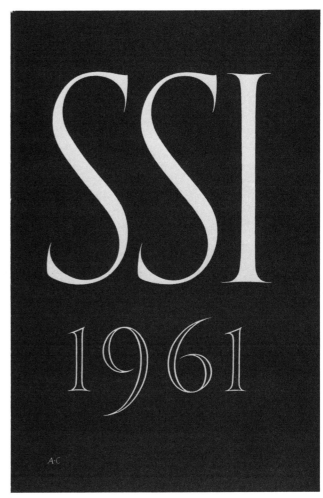

PRIVATE VIEW 20TH JUNE 7-9 P.M.

ROEHAMPTON INSTITUTE · DIGBY STUART
COLLEGE · ROEHAMPTON LANE · LONDON SW15

AN EXHIBITION

OPEN TO THE PUBLIC 21ST-23RD JUNE
RICHARDSON HALL · DIGBY STUART COLLEGE
FRIDAY 21ST 4-8 P.M. WEEKEND 3-6 P.M.

CALLIGRAPHY &
BOOKBINDING

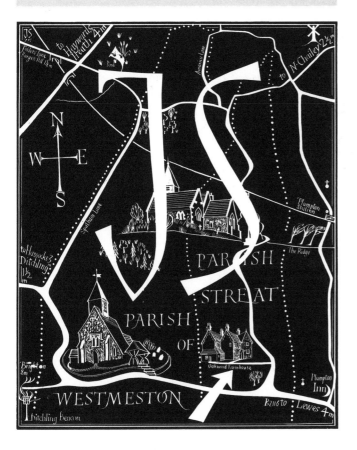

Above
Ann Camp
Catalogue cover for an exhibition. $7\frac{1}{4}'' \times 4\frac{3}{4}''$
(18.5 × 12 cm). 1961

Above left
Lindsay Castell
Invitation to an exhibition.

Left
John Skelton
Road map to Oakwood Farmhouse. $8\frac{1}{4}'' \times 7''$
(21 × 53.5 cm). 1975

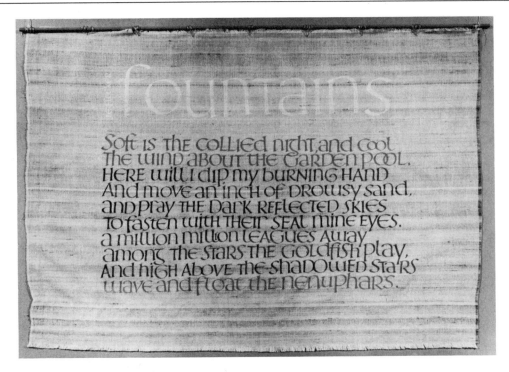

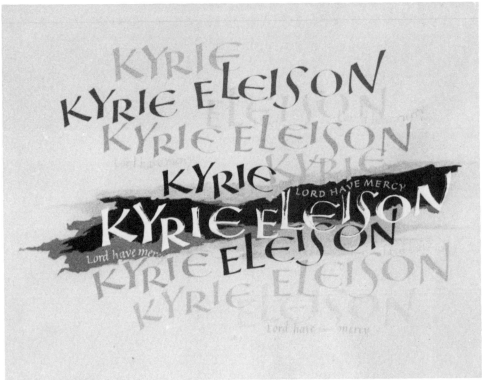

Above
Alison Urwick
Fountains by J E Flecker. Brush lettering on silk in gouache and shell gold. 22″ × 32″ (56 × 81 cm). 1986

Below
Stan Knight
Kyrie Eleison. A framed panel with gouache, shell gold and burnished gold. The design was suggested by the music of Bach's B Minor Mass where the voices intertwine, reach a climax and then diminish.
25 × 37 cm (9¾″ × 14½″). 1981
(Victoria and Albert Museum L.20–1985.)

Opposite page
David Howells
Oberon to Puck, from *A Midsummer Night's Dream* II, 1. Written with a pen and black and green watercolour on pale green paper. 22″ × 18″ (56 × 45.5 cm). 1972

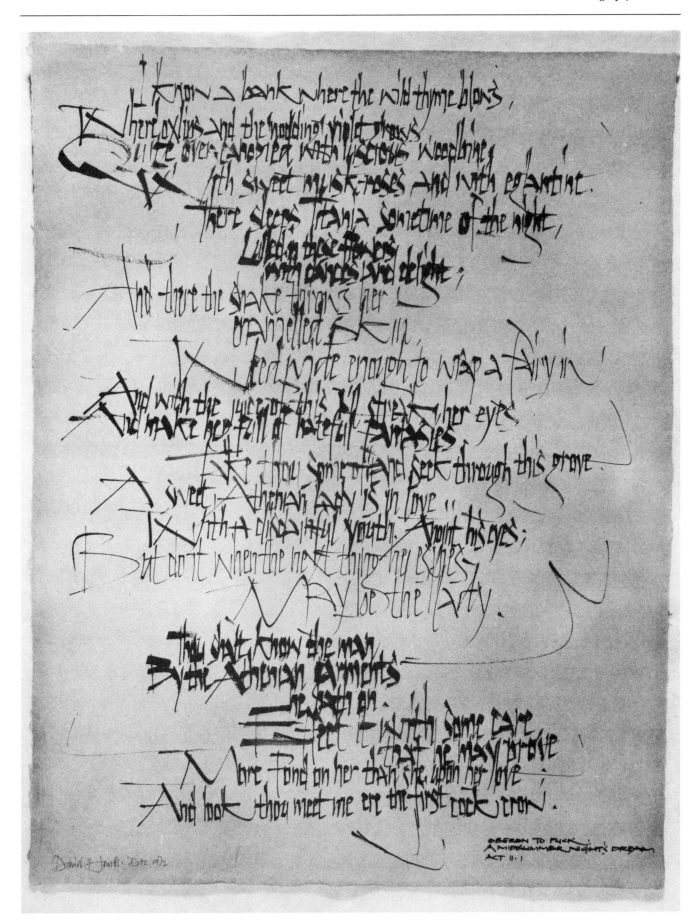

I know a bank where the wild thyme blows,
Where oxlips and the nodding violet grows,
Quite over-canopied with luscious woodbine,
With sweet musk-roses and with eglantine.
There sleeps Titania sometime of the night,
Lulled in these flowers
with dances and delight;
And there the snake throws her
enamelled skin,
Weed wide enough to wrap a fairy in.
And with the juice of this I'll streak her eyes,
And make her full of hateful fantasies.
Take thou some of it and seek through this grove.
A sweet Athenian lady is in love
With a disdainful youth. Anoint his eyes;
But do it when the next thing he espies
May be the lady.
Thou shalt know the man
By the Athenian garments
he hath on.
Effect it with some care,
that he may prove
More fond on her than she upon her love;
And look thou meet me ere the first cock crow.

David J. Howells, Dec. 1972

OBERON TO PUCK
A MIDSUMMER NIGHT'S DREAM
ACT II·1

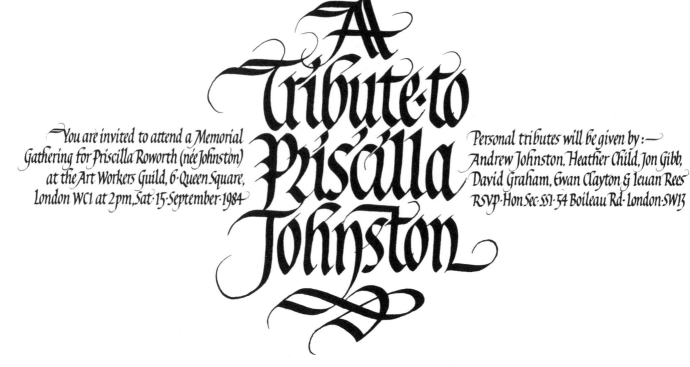

You are invited to attend a Memorial Gathering for Priscilla Roworth (née Johnston) at the Art Workers Guild, 6·Queen Square, London WC1 at 2pm, Sat·15·September·1984

A Tribute·to Priscilla Johnston

Personal tributes will be given by:— Andrew Johnston. Heather Child, Jon Gibb, David Graham, Ewan Clayton & Ieuan Rees RSVP·Hon·Sec·SSI·54 Boileau Rd·London·SW13

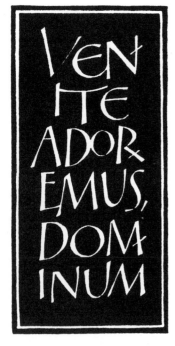

VEN ITE ADOR EMUS, DOM INUM

You are invited to A THANKS GIVING FOR IRENE

Irene Wellington died on September·18th

A MEETING TO REMEMBER HER

will be held at the Art Workers' Guild Queen's Square·London WC1 at 2·00pm on Saturday·December 1st. Personal tributes will be given then by her family, calligraphers and friends.

RSVP [If accepting] before November 15th to Hon·Sec·SSI: 54·Boileau Road·London SW13

Top
Ieuan Rees
A Tribute to Priscilla Johnston.
Invitation to a memorial service. 5″ × 9¼″ (12.5 × 23.5 cm). 1984

Above left
Stan Knight
Christmas greeting: lino-cut print in dark green with initial V overprinted in red, on Bockingford watercolour paper. Image 9 × 4.5 cm (3½″ × 1¾″). 1985

Above right
Ann Hechle
Invitation to a meeting. Printed black on white card. 5½″ × 8¼″ (14 × 21 cm).

Weight and power, Power growing under weight.

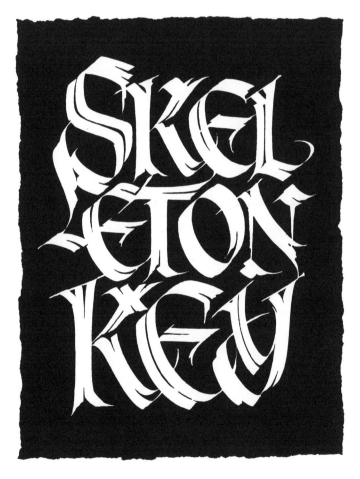

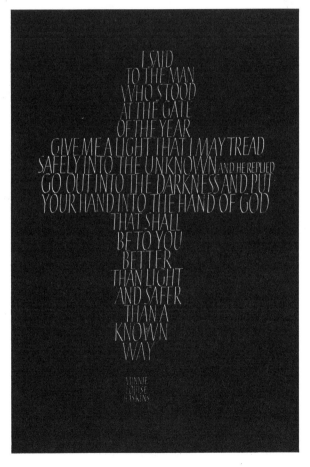

Top
Tom Perkins
Quotation from *The Prelude* by William Wordsworth. Written with an Automatic pen.

Above left
Madeleine Dinkel
Skeleton Key. Display lettering for reproduction on posters and for other publicity purposes. Written with bamboo pen. 17.5 cm (6¾″) high. Reproduced to various sizes – poster 25 cm (9¾″) high – and also reversed black to white.

Above right
Charmian Mocatta
'I said to the man who stood at the gate of the year,' by Minnie Louise Haskins. Written with a broad pen and gum ammoniac on black paper, then gilded. 62 × 41 cm (24¼″ × 16″). 1986

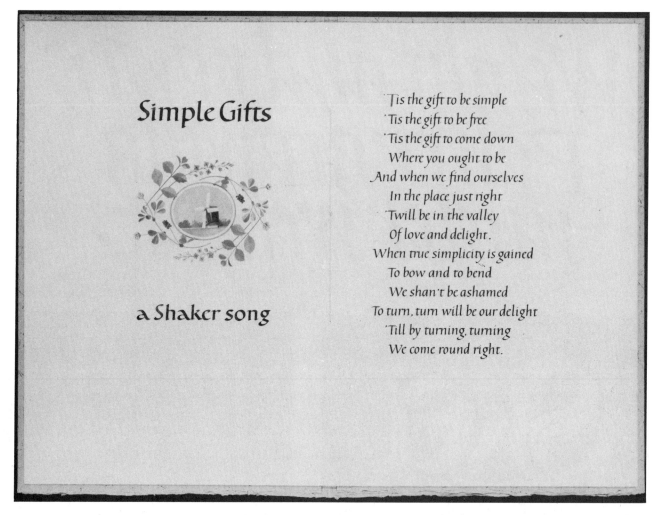

Simple Gifts

a Shaker song

'Tis the gift to be simple
'Tis the gift to be free
'Tis the gift to come down
Where you ought to be
And when we find ourselves
In the place just right
'Twill be in the valley
Of love and delight.
When true simplicity is gained
To bow and to bend
We shan't be ashamed
To turn, turn will be our delight
'Till by turning, turning
We come round right.

Above
Wendy Westover
Simple Gifts, a Shaker song. 32.2 × 42.7 cm
(12½″ × 16¾″). 1986

Right
Sidney Day
Goldcrest. Gilding and watercolour on
vellum. 5½″ × 5½″ (14 × 14 cm). 1986

Opposite page
Marie Angel
'H for Hare, and Hoopoe' from *Angel's
Alphabet*. Painted on paper in watercolour
and gouache: soft blue, fawn and grey; the
animals in natural colours; and the capital
H in blue. Image size 11.5 × 10 cm
(4½″ × 4″). 1986

Marie Angel
'P for Pig, Penguin and Parrot' from *Angel's
Alphabet*. Painted on paper in watercolour
and gouache: multicoloured background;
the animals in natural colours; and the
capital P in green. Diameter of circle 9 cm
(3½″). 1986

GOLDCREST ·: Regulus regulus

The smallest bird in Britain, the Goldcrest is very active
pugnacious and extremely noisy · Builds its elaborate nest
of spiders webs, feathers and moss at a height of 50 feet most
often in conifers · Spends much time searching for insects,
flies and spiders in the tops of conifers · The female lays up to
10 eggs from April to June & incubation takes some 15 days

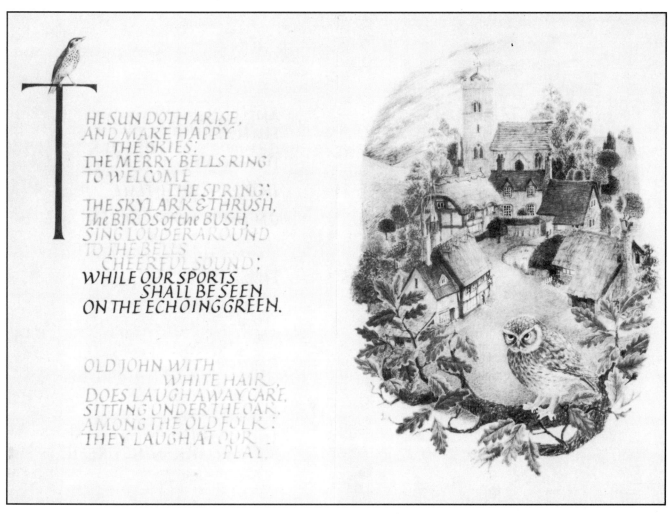

Marie Angel
Calligraphy and miniature for *The Echoing Green* by William Blake. Page size 8″ × 5″ (20.5 × 12.5 cm). 1985
(Commissioned by Michael Taylor.)

THE BAGNALL
GALLERY
WHICH
EXTENDS THE
CRAFTS COUNCIL'S
GALLERY AND
INFORMATION
CENTRE WAS
OPENED BY
H·R·H
THE PRINCE
OF WALES
ON
2 FEBRUARY
1982

Arabian
and Islamic
Studies

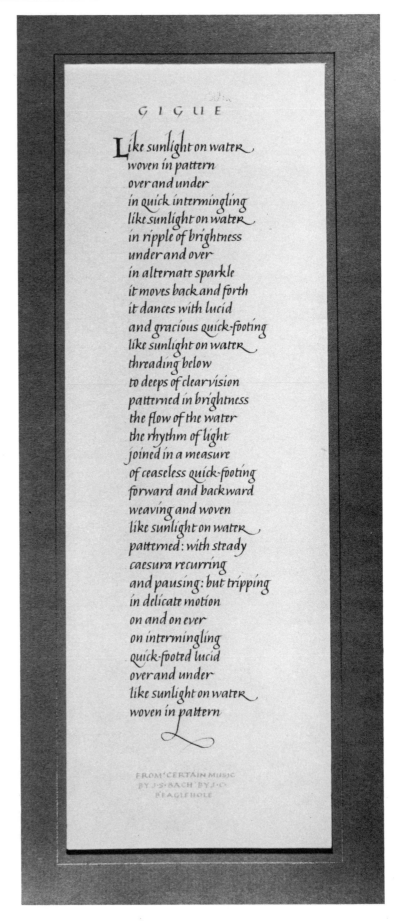

GIGUE

Like sunlight on water
woven in pattern
over and under
in quick intermingling
like sunlight on water
in ripple of brightness
under and over
in alternate sparkle
it moves back and forth
it dances with lucid
and gracious quick-footing
like sunlight on water
threading below
to deeps of clear vision
patterned in brightness
the flow of the water
the rhythm of light
joined in a measure
of ceaseless quick-footing
forward and backward
weaving and woven
like sunlight on water
patterned: with steady
caesura recurring
and pausing: but tripping
in delicate motion
on and on ever
on intermingling
quick-footed lucid
over and under
like sunlight on water
woven in pattern

FROM 'CERTAIN MUSIC
BY J·S·BACH' BY J·C·
BEAGLEHOLE

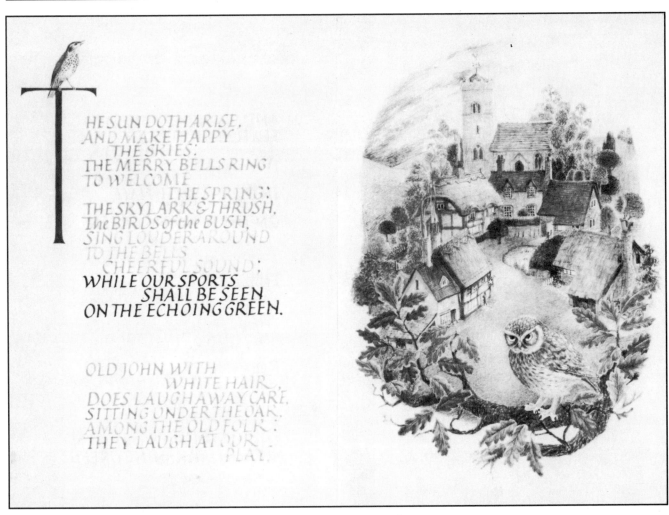

THE SUN DOTH ARISE,
AND MAKE HAPPY
 THE SKIES:
THE MERRY BELLS RING
TO WELCOME
 THE SPRING;
THE SKYLARK & THRUSH,
The BIRDS of the BUSH,
SING LOUDER AROUND
TO THE BELLS
 CHEERFUL SOUND;
WHILE OUR SPORTS
 SHALL BE SEEN
ON THE ECHOING GREEN.

OLD JOHN WITH
 WHITE HAIR
DOES LAUGH AWAY CARE,
SITTING UNDER THE OAK,
AMONG THE OLD FOLK:
THEY LAUGH AT OUR
 PLAY,

Marie Angel
Calligraphy and miniature for *The Echoing Green* by William Blake. Page size 8″ × 5″ (20.5 × 12.5 cm). 1985 (Commissioned by Michael Taylor.)

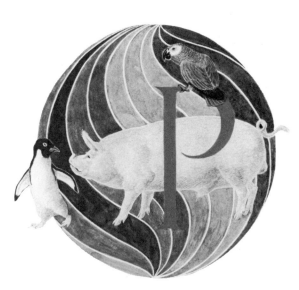

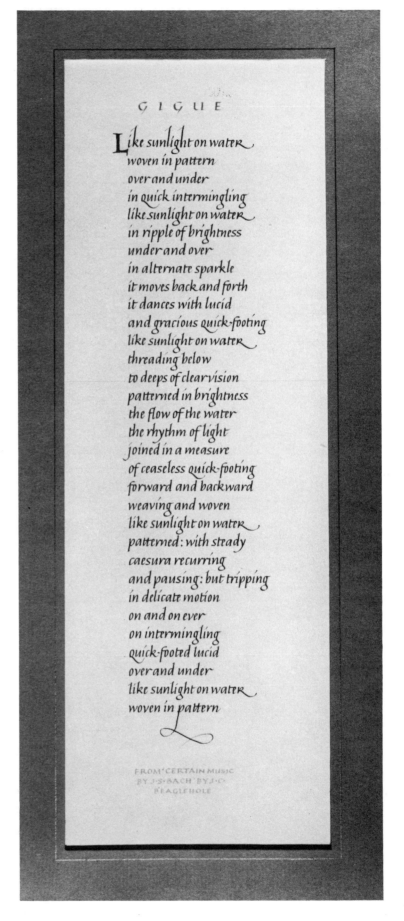

THE BAGNALL
GALLERY
WHICH
EXTENDS THE
CRAFTS COUNCIL'S
GALLERY AND
INFORMATION
CENTRE WAS
OPENED BY
H·R·H
THE PRINCE
OF WALES
ON
2 FEBRUARY
1982

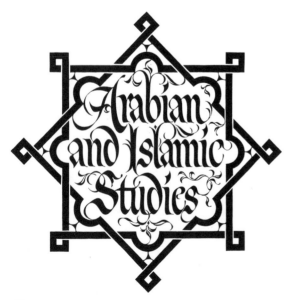

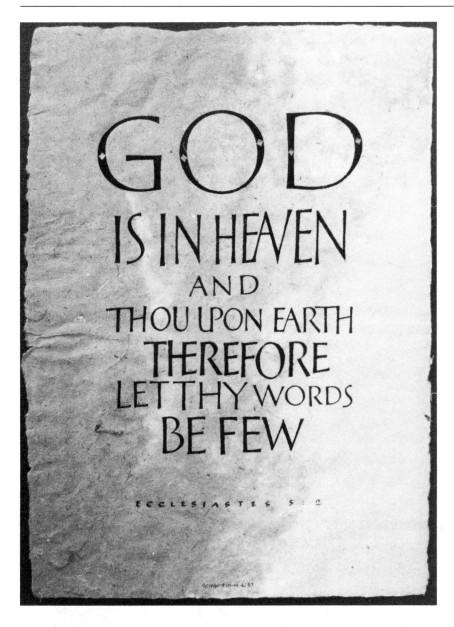

GOD
IS IN HEAVEN
AND
THOU UPON EARTH
THEREFORE
LET THY WORDS
BE FEW

ECCLESIASTES 5:2

Opposite page, above left
Tom Perkins
Painted inscription on Chinese silk.
7′6″ × 21¾″ (228.5 × 55 cm). 1982
(Commissioned by the Crafts Council.)

Opposite page, below left
Madeleine Dinkel
Arabian and Islamic Studies. Brushwork
original. 20 cm (7¾″) high. Reproduced on
book jacket (turquoise on wine-red
ground), on title page (printed in black),
on leather binding (blocked in gold) and
on cloth binding (blind blocked).

Opposite page, right
Joan Pilsbury
'Gigue' from *Certain Music by J S Bach* by J C
Beaglehole. Written on paper with stick ink,
a burnished gold initial and a blue title.
Mounted panel 17″ × 8″ (43 × 20.5 cm).
1984

Left
Gerald Fleuss
Ecclesiastes V, 2. Gouache and shell gold on
paper handmade by the scribe.
38.5 × 29 cm (15″ × 11¼″).

Below
Gaynor Goffe
Quotation from *Walden* by Thoreau. Printed
as Christmas card.

Only that day dawns
to which we are awake /
There is more day to dawn /
The sun is but a morning star

WALDEN : THOREAU

Above
Tom Perkins
These letters for reproduction were built up
with a fine felt-tip pen on paper.

Centre
Donald Jackson
Painted sign from Cranks Wholemeal Bakery.

John Woodcock
Small is Beautiful. Invitation to an exhibition.
Printed black on yellow. 10 × 21 cm
(4″ × 8¼″). 1986

Below
Kenneth Breeze
Playing cards designed for the Arthritis and
Rheumatism Council. 1986

Opposite page, above
Ann Hechle
Sound. Poster, one of a series of 5 panels
that show how calligraphy can be used to
explore the English language. Original
written on vellum with quills and steel pens,
and with stick ink, brown and reddish-
brown watercolour. 17″ × 24½″
(43 × 13 cm) approx. 1981

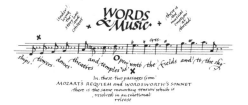

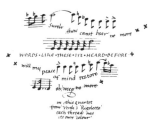

Michael Renton
Book plate engraved on wood. Printed in sepia. Presented to HM the Queen by the National Book League. 1984

Michael Renton
Book plate engraved on wood for Kinn Hamilton McIntosh. Printed in light blue. 1986

Michael Renton
Book plate engraved on wood for John Gray. Printed in black. 1984

Changing views and educational opportunities

Ann Camp

Ann Camp is internationally well known as one of the foremost teachers of calligraphy in Britain. She and her assistant lecturers attract students from many parts of the world: other European countries, USA, Canada, Australia and New Zealand. She is the author of **Pen Lettering**, *first published in 1958 and described as a classic.*

It says much about her teaching that eight of her students, five of them American, are currently Fellows of the Society of Scribes and Illuminators. She won a Royal Scholarship to the Royal College of Art, London, where she studied with Dorothy Mahoney, taking her Diploma in 1946, the same year that she was unanimously elected to the SSI. She has taught in several art schools in London and played a major part in setting up the calligraphy and bookbinding courses at Digby Stuart College, Roehampton Institute of Higher Education, where she is a part-time lecturer in calligraphy. She has carried out many important commissions and exhibited widely in the past but is now primarily concerned with teaching. Her work is in a number of major collections and has been reproduced in several books on calligraphy.

In 1951, in the Foreword of *The Work of Jan van Krimpen*, by John Dreyfus, Stanley Morison wrote, '...calligraphy and typography,... are not to be regarded as the unrecognizable poor relations of the fine arts of painting and drawing, etching or wood-engraving. Because calligraphy and typography refuse to submit to all kinds of experiment it does not follow that they are not in any sense to be reckoned as aspects of art'.[1] Later in the same Foreword he wrote, 'Whether the complete emancipation now enjoyed by painting, from all control academic or other, is in the best interests of "art" is a question that does not require to be discussed here. It is only necessary to say that calligraphy and typography remain what painting and drawing once were: a means of unambiguous communication to the mind through the eye. To communicate with the utmost clarity, ease and appropriateness to the idea, is no easy task. Success is rendered more difficult by conceding any and every demand for personal or individual satisfaction'.[2]

Probably in the early fifties, these views would have been shared by the majority of British scribes, with the exception that most scribes would certainly have expected to achieve some personal and individual satisfaction in their work, even if it was exercised with restraint. This may seem strange to some of the younger generation of scribes, many of whom are aiming primarily at self expression and originality.

The purpose of this article is to give a background image of the changing and varied approaches in traditional and so-called 'expressive' calligraphy and, other than Edward Johnston, not to comment on the work of individual scribes in Britain, many of whom are friends and colleagues.

Let us then consider the changing attitudes which have radically altered some people's approach to calligraphy. In his Author's Preface to *Writing and Illuminating, and Lettering*, Edward Johnston wrote, 'The beginner's attitude is largely, and necessarily, imitative, and at this time we should have much to hope from a school of Artist-Beginners who would make good construction the only novelty in their work. We have almost as much – or as *little* – to be afraid of in Originality as in Imitation,... Perhaps we trouble too much about what we "ought to do" and "do": it is of greater moment *to know what we are doing and trying to do*. In so far as tradition fails to bound or guide us we must think for ourselves and in practice make methods and rules for ourselves: endeavouring that our work should *be effective* rather than have "a fine effect" – or *be*, rather than appear, good – and following our craft rather than making it follow us. For all things – materials, tools, methods – are waiting to serve us and we have only to find the "spell" that will set the whole universe a-making for us'.[3]

The words 'endeavouring that our work should... *be*, rather than appear, good – and following our craft rather than making it follow us' are important if one wants to understand the attitude of British scribes from the time of the Johnston revival probably up to the fifties. The attitude of Johnston and his followers was largely influenced by Lethaby who said, 'Most simply and generally art may be thought

of as the well-doing of what needs doing'.[4] In this remark, Lethaby was following the philosophy of William Morris who believed in honest and direct workmanship. Honesty was all important, and was a reaction against some of the shoddier products of the Industrial Revolution. Honesty of craftsmanship was to Morris, and many others, exemplified in the work of the Middle Ages, when craftsmen played such an important role in the community in almost every sphere of daily existence.

Lethaby also said, 'Nothing done for the LOOK looks well'.[5] The look was obviously very important, but the idea was, that the purpose of the work *itself* should control and guide it, under the proper influence of rightly used tools, materials and methods. The design should be the direct outcome of good methods of work, not a set of preconceived ideas applied to it. Truth to materials was paramount. In other words, in calligraphy, the design was evolved by the use of direct broad-pen statements following the author's wording and intention (the sense and purpose of which would suggest appropriate emphasis, decoration and arrangement) rather than in conceiving a grand or striking idea or 'effect', and making the words fit it, without due consideration to their fitness for purpose.

That attitude is in sharp contrast to what many people are doing today, that is imaginatively playing with the work, extending it in many directions to create visual images and expressive ideas, where mood, colour, texture and dynamic use of space often take precedence over legibility and 'unambiguous communication'. Also many people now seem to be striving for a 'fine effect' rather than being concerned with whether their work is 'effective'. Experiment and innovation are essential factors in any creative art, however they are usually at their best when they are based on sound foundations of knowledge, skill and experience. Lethaby wrote, 'Usually the best method of designing has been to improve on an existing model by bettering it a point at a time; a perfect table or chair or book has to be very well bred'.[6] 'Bettering it a point at a time' would seem to be a good method whether one works in traditional or innovative expressive ways. If one studies the progress of the best of the innovative scribes' work, it will usually be seen to have evolved from fairly conventional statements to more complex and experimental ideas, it may be paralleled to abstract painting, where the best abstract painters had an academic basis from which to abstract.

The use of the words 'expressive' and 'innovative' (as they are used here) should perhaps be explained. All lettering and calligraphy, if it has any particular merit, is expressive, and may well be innovative (or inventive) whether it is traditional or not. This applies even to Roman capital letters which often show great subtlety and inventiveness in the interpretation of their forms. Whilst this aspect of letter design has been taken into account, the words 'expressive' and 'innovative' have been used here to apply to those forms of work which are moving away from tradition into more experimental and expressionist methods of approach.

It may sound from these divisions as though calligraphy is split into two halves, the traditionalist and the modern, but this is not always the case, not at any rate in Britain, where it will be found that the two approaches overlap. A number of scribes who carry out traditional work, for example, certificates, addresses, work for reproduction and other practical commissions, also experiment with free and expressive ideas. Perhaps to some people only the more experimental work is considered to be 'art', whilst the more traditional work is seen to be less creative and no more than routine 'craft'. This is not necessarily the case. A seemingly straightforward traditional work may be as highly creative, in its own way, as the free expressive one, but usually only the trained eye can recognise it because generally its creative qualities are so much more subtle and restrained.

There is a danger (if it is studied unimaginatively) that in some people's hands traditional work will become fossilised but there is also the danger that in other people's hands experiment and innovation will go too far and may lead to degeneration. Some people are taking great risks by exploiting the craft in an egocentric way, and denying themselves the wider vision of understanding it by 'following it' through its various stages of growth and development, both historic and contemporary. There is a present fashion which causes people to admire strong impact, skill and energy of line more than good fundamental form. This can unfortunately sometimes lead to an exaggerated emphasis on the appearance or 'look' at the expense of inner content, and runs the risk of becoming an empty display of virtuosity.

As in all changing attitudes, those of calligraphers are almost inevitably influenced by cultural change, and also to a certain extent by current fashion. The

[1]John Dreyfus: *The Work of Jan van Krimpen*, page vii
[2]*Ibid.* page viii
[3]Edward Johnston: *Writing and Illuminating, and Lettering*, page xviii (1978 edition)

[4]*W R Lethaby 1857–1931: Architecture, Design and Education*, exhibition catalogue, page 18 and page 37
[5]*Ibid.* page 24
[6]*Ibid.* page 19

views of Johnston were based on an idea of service and usefulness in the making of 'Things', and it is a compliment to his teaching that most of his students developed very individual characteristics in their work, even though it was mainly traditional. It was in his later years that Johnston ventured into hands which were a sheer tour de force in giving a rich almost gothic texture to the page. These hands were evolved through personal development from models based on English tenth-century forms. His work was rooted in very thorough historical research and then moved on into highly personal styles of writing. James Wardrop said of him, 'he extended the boundaries of writing to a point perhaps never attained before, except maybe by the Chinese'.[7]

Many ideas of today stem from very different attitudes and approaches which reject tradition and historical research, and count self-expression as perhaps the most vital factor in producing works which are considered to be 'art' rather than 'craft'. This often leads to poor and uninformed copying of established scribes' work. In many cases the idea of usefulness hardly comes into consideration any more than it does in so much of contemporary painting, and truth to materials is often bypassed in the interests of individuality and imposed style.

Good calligraphers communicate on many levels. Generally speaking, some are primarily traditional in their approach; some are traditional *and* innovative and expressive in their work; some started as traditional scribes and have moved primarily into expressive experimental work; and a few have always been mainly expressive and experimental. There are many approaches, all of which are valid in their own way. The calligrapher's work can be immensely varied; it can be formal and elaborate giving a sense of occasion, informal and ephemeral, or highly personal and experimental, and on occasion idiosyncratic or just fun.

It would be interesting if someone could write a full critical survey of calligraphy in Britain since the Johnston revival, with particular emphasis on what has happened since the last war. What influences brought about the changes? Who instigated them? Where are they leading to – and why? David Jones certainly had an influence, and some of Johnston's students and his students' students have explored new avenues and extended the sphere of his work; some much more than others. Their names are well known to all serious calligraphers, and are well represented in this book. From the sixties onwards

German calligraphers have had an influence; for example, Karlgeorg Hoefer, Friedrich Poppl, Hermann Zapf and others. The German attitude to calligraphy was always very different from the British one, having from the beginning of the revival a much more experimental approach, as instanced in the work of Rudolf Koch who believed in making a new start rather than studying historical forms. He wrote, 'We do not want to rely on the masters of the past because we do not want to write books which appear identical to the old ones. Our intention is to express ourselves in a new way and work as we see fit because we have our own and independent views on how to go about it'.[8] Perhaps Rudolf Koch did not fully appreciate Johnston's intentions in historical research, which relied more on extracting methods from historical examples than on slavish imitation of styles of writing and letter-making. As he said, 'one may lawfully follow a method without imitating a style'.[9]

In the USA great changes have taken place. One would expect this in a vast country which was never wholly influenced by Johnston and his school; which draws its influences from as far afield as Germany, China and Japan as well as Britain; and where the subject is much more closely linked with graphic design than it is in Britain. Some of these American influences are spreading to these shores and opening up new vistas alongside the more traditional approach, which is still highly valued and practised in Britain today.

It is perhaps natural that Britain not only revived traditional calligraphy but also remains the leader in it. A country with many ancient institutions, and a Monarchy and Peerage, provides the obvious ceremonial occasions which are commemorated by the presentation of illuminated addresses, letters patent, charters, scrolls and other wholly handmade documents of importance, usually written on vellum and often embellished with heraldry and gilding. These perhaps represent the fountain-head of formality. Expressive calligraphy in Britain has grown out of traditional work and developed alongside it. It has not replaced it. It is, as it were, another branch of the tree, but it shares the same roots in the history and evolution of scripts.

Educational opportunities

Before, during and after the last war, calligraphy was taught in almost every art school in the British Isles. It was one of the subjects included in the National

[7]Edward Johnston, edited by Heather Child and Justin Howes: *Lessons in Formal Writing*, page 34
[8]*Ibid.* pages 65–66

[9]Edward Johnston: *Writing and Illuminating, and Lettering*, pages xvii–xviii (1978 edition)

Diploma, which was a B.A. equivalent course. It was also taught at the Royal College of Art, a post-graduate college, where the diploma is equivalent to an M.A.

In 1953, calligraphy received a severe educational blow when it was discontinued at the Royal College of Art. In the early sixties when the National Diploma was replaced by the Diploma in Art and Design (now B.A.), it received a second educational blow when it was not included in the new courses, and was almost without exception, phased out as an examination subject. Reigate School of Art was the one exception and has continued to the present time with the Surrey Diploma. The courses there are being restructured, and it is to be hoped that calligraphy will continue to be recognised in the new courses as a major subject with sufficient time for serious study.

Roehampton Institute of Higher Education started a one-year Diploma course in calligraphy and bookbinding in 1979 at Digby Stuart College. It now runs one-year courses which lead to a Certificate in Calligraphy and Bookbinding, a Diploma in Calligraphy and a Diploma in Advanced Calligraphy.* At the present time Reigate School of Art and Roehampton Institute are the two main places in Britain for full-time study in calligraphy. Reigate School of Art has become well known for its heraldry and illumination, while the courses at Roehampton Institute concentrate primarily on studying calligraphy.

It is paradoxical that when calligraphy was widely taught in Britain, few people outside art schools

*The Diploma courses can also be taken part-time over two years.

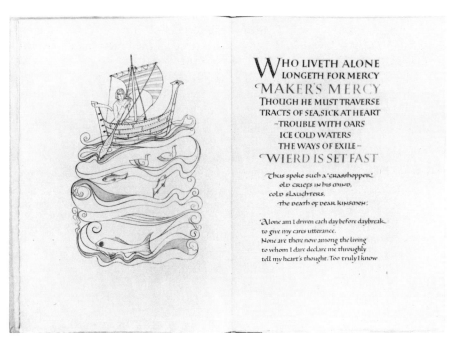

Ann Camp
The Wanderer, an Anglo-Saxon poem from *The Earliest English Poems*, published as a Penguin Classic. Written out by Ann Camp, 1973, and illustrated by Alison Urwick, 1976, by permission of the translator, Michael Alexander. Written on buff-coloured handmade Dover paper. Versals in top two lines crimson, in third and ninth lines gold, in other lines viridian green. Uncials and initial A crimson. Text black. Illustration in black outline with washes of pink, green and buff, heightened by touches of gold. Double-page size 24″ × 16¾″ (61 × 42.5 cm).

A man should forbear boastmaking
until his fierce mind fully knows
which way his spleen shall expend itself.

Ann Camp
Three lines of the text of *The Wanderer*, four-fifths of full size. Initial crimson. Text black.

knew what it was. Now that professional educational opportunities are so scarce, interest in the subject is booming. Adult education institutes throughout the country are putting on courses, some good, some bad and some indifferent. The Society of Scribes and Illuminators runs a number of workshops, and there are also residential courses and workshops which are advertised in the S.S.I. Journal. There is however a real difficulty in finding good teachers, as it is nearly twenty-five years since there was sufficient professional education. The demand is great, which means that after as little as a year or so in adult education courses some people are walking round to the other side of the desk and teaching calligraphy. There is a great need to educate more young people and to train a new generation of teachers. We can hardly return to the days when a calligraphy student often studied in an art school or college for as long as six to nine years, but it would be a considerable help if there were a few more schools which could encourage the young to take a serious course of study in calligraphy and allied subjects.

The increased amateur interest in calligraphy is very encouraging but if standards are to be maintained we need a larger core of professionals. The last of the scribes who were educated at art schools (except for those from Reigate School of Art, and perhaps a few others) are now in their late forties, and a large number of the older scribes have died in recent years. The Society of Scribes and Illuminators is concerned about how few scribes are applying for Fellowship, and a special scheme of Associateship has recently been introduced so that the Society can help candidates to achieve the required standard.

The Society of Scribes and Illuminators' recent exhibitions have awakened widespread interest and perhaps sometime the day will come for a complete reappraisal of calligraphy, its educational needs and its role in present society. In the days of the Johnstonian revival calligraphy had a very considerable influence on lettering and typographic design, both in Britain and abroad, particularly in Germany, and a number of older and past craftsmen and lettering designers have used calligraphy extensively as a starting point for interpretation into lettering and type design. One thinks of Will Carter, Jan van Krimpen, Friedrich Poppl and Hermann Zapf to name just four: and Jan Tschichold certainly recognised the educational value of calligraphy for typographers. A fundamental understanding of calligraphy could be of great value to all who use letters because, to quote Edward Johnston, 'For over a 1000 years (between A.D. 400 and 1500) the broad nib was the principal formative tool in the development of writing. From the early, stylus-made skeleton letters, it produced the conventional finished shapes and varieties which we now use (familiar to most of us mainly in print). The finished shape-and-structure of the common alphabet is, in fact, bound up with the shape-and-action of our pen'.[10] And again in his Author's Preface to *Writing and Illuminating, and Lettering* he says, '... the use of the pen – essentially *the* letter-making tool – gives a practical insight into the construction of letters attainable in no other way'.[11] Calligraphy provides an awareness of the design of letters and their evolution, leading naturally to a study of its historical background, which is invaluable to all who use letters. If it were seriously studied again in more places, it could once again become a sound influence on many new methods of letter designing, including digital type designing in our computer age, which frequently sinks to a very low level through lack of understanding of good letterforms and their origins.

Calligraphy has a great value in the making of beautiful original books and documents, with traditional tools, materials and methods; it can be used in graphic design and work for reproduction; it can be a basis for letter design for all who use letters in whatever medium; it can also be expanded into free expressive work; and it has immense educational value.

It will be interesting to see which directions calligraphy will take in the next decade.

A. C. 1986

[10]Edward Johnston, edited by Heather Child: *Formal Penmanship*, page 121

[11]Edward Johnston: *Writing and Illuminating, and Lettering*, page xi (1978 edition)

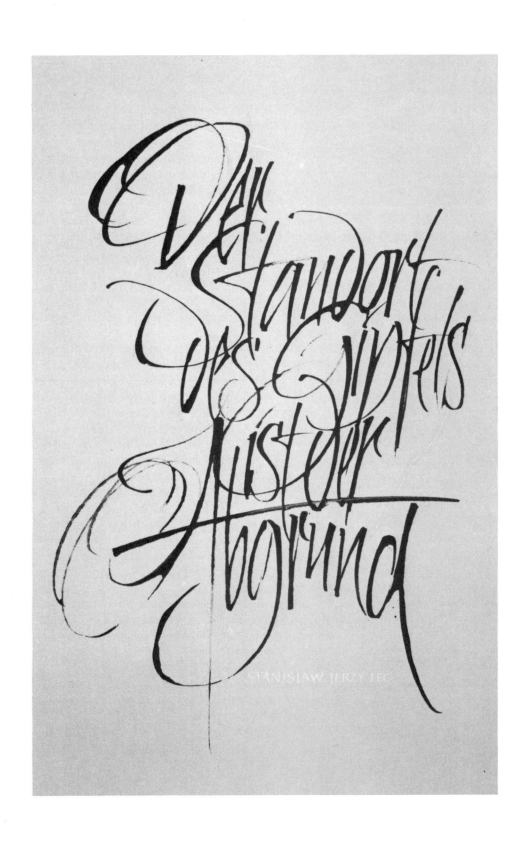

Calligraphy in Europe

Austria, Germany and Switzerland

Parallel with the calligraphic movement which was taking place in England at the beginning of the century, similar but independent movements were beginning in Europe. The chief exponents of far-reaching reforms, besides Edward Johnston in England, were Rudolf von Larisch in Vienna and, rather later, Rudolf Koch in Germany. The aims of these men were to improve the standard and quality of the arts of writing and lettering which were then at a low ebb and to give significance once more to the work and status of the scribe. That they succeeded in this task can be seen in the vitality, variety and technical skills of penmanship as it has developed, as well as in the revitalisation of typography.

Rudolf von Larisch, who was sixteen years senior to Edward Johnston, was born in Verona in Italy in 1856 and died in Vienna in 1934. For many years he was an official in the Chancery of the Austrian Emperor Franz Josef, archivist of the Order of the Toison d'Or and Keeper of the Hapsburg Records. Such appointments gave him ample opportunity for the study of historical manuscripts in a country where long-established cultures from East and West had influenced styles of writing over the centuries. The debased penmanship of the more recent records so repelled him that he became fired with a passionate desire for handwriting reform. He published a pamphlet *Zierschriften im Dienst der Kunst* (Decorative Writing and Lettering in Art) and this led to his appointment as lecturer in Lettering at the Vienna School of Art in 1902 and marked the beginning of his teaching career, just a year after Johnston had begun teaching at the Royal College of Art in London.

Rudolf von Larisch wrote numerous articles in the press in an effort to awaken the interest of the public and he produced various portfolios with reproductions of historical examples of formal writing. His most important work, *Unterricht in Ornamentaler Schrift* (A Manual of Instruction in Decorative Writing and Lettering), appeared in 1906 and had a wide influence in German-speaking countries. He believed calligraphy to be a natural form of creative self-expression and that penmanship therefore was of genuine educational value. He did not consider calligraphy an end in itself, a mere exercise in virtuosity, but encouraged his students to develop their inventiveness and to carry out experiments in writing and lettering on a variety of materials such as wood, glass, metal, pottery and textiles, in order to discover the varying techniques and methods of expression each demanded. He emphasised the balance between the letters and the background and the need for unity and rhythm in the work whatever its purpose and recognised that the discipline of learning calligraphy could inspire valuable artistic creativity.

This was in contrast to Johnston's teaching which was based mainly on the study of traditional hands and on the principles arising from his researches into historical scripts. Von Larisch felt that the perceptive scribe should express intuitive feeling in his work, that the pattern of the written letters on the page and the rhythm of the writing itself should harmonise. He taught the proper handling and use of all kinds of writing instruments, many of which he developed by experiment in co-operation with Rudolf Blanckertz of the well-known German firm of pen manufacturers, who was himself a tireless worker for calligraphy and founder of the Handwriting Museum in Berlin.

Although von Larisch and Johnston began their studies independently and their teaching methods differed, their aims and conclusions were sympathetically related, and when they met in London in 1909 they immediately developed a mutual understanding and liking for one another.

Previous page
Gottfried Pott
Aphorism by Stanislaw Jerzy Lec.
Written with a ruling pen and stick ink
on light-blue paper. 42 × 30 cm.
(16½″ × 11¾″) 1984

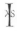

Left

Rudolf von Larisch

A tribute to Anna Simons, in gratitude for her work as a teacher, artist and pioneer, in the form of a certificate. Reduced. 1932

Right

Anna Simons

Plate I from *Die Geschichte der Schrift*, a portfolio of scripts for Verlag Heinz & Blanckertz, showing examples from 3rd century B.C. to 7th century A.D. Reduced. *c* 1930

Von Larisch had a number of assistants, the best known being Dr Otto Hurm and Hertha Ramsauer, who became von Larisch's wife and carried on his work in Switzerland after his death.

Another important teacher of calligraphy was Anna Simons, who was born in 1871 and died in 1951. As women were not allowed to train in art schools in Prussia in the late nineteenth century she went to London in 1896 to study at the Royal College of Art, just when the influence of the Arts and Crafts Movement was growing, with London the centre of it. She joined Edward Johnston's class in 1901 and quickly became one of his best students. He said of her, 'She has a natural aptitude for the work and a sincerity and directness of outlook which enabled her to master the essential elements very rapidly and later to develop them into her own practical and beautiful work.'

After obtaining her diploma at the Royal College of Art, Anna Simons returned to Germany where she began to teach Johnston's methods with enthusiasm. She was largely instrumental in bringing new vigour to German scripts which had lost much of their vitality. In 1905 the Prussian Ministry of Commerce arranged a lettering course for art teachers at Dusseldorf, the first of its kind, and Count Harry Kessler, already impressed by Johnston's work when they met in London the year before, saw this as a further opportunity of introducing his teaching into Germany. Johnston himself was not available but he recommended Anna Simons, who conducted the course with outstanding success. The Germans were already alive to the revival of formal writing, lettering and printing, and great interest was aroused by this lettering course. It became a yearly affair and Johnston's methods were publicised by Anna Simons and her students.

Naturally this growing interest led to a demand for a translation of Johnston's manual *Writing and Illuminating, and Lettering.* This difficult task was entrusted to Anna Simons in 1910. Her knowledge of English and understanding of formal penmanship, combined with her conscientiousness, enabled her to carry it out with success. Some two years later she translated into German the text of Johnston's portfolio, *Manuscript and Inscription Letters.*

Lettering and typographic design in Germany and Switzerland were the first to benefit from the surge of interest in craftsmanship which, stemming from William Morris and his circle, swept over Europe in the early years of the twentieth century. In Germany the movement was led by such men as Otto Echmann, Rudolf Koch, Fritz Helmuch Ehmcke, Walter Tiemann and Emil Weiss and it had the encouragement of the art schools to support it.

At this period the Germans were moving away from their traditional Gothic hands and beginning to use roman types regularly. Stanley Morison wrote in 1926 'The school of calligraphers practising the teaching of Johnston and Gill, which has arisen since the year 1905, has in its hands the whole of German type design, with the exception of the cruder kinds of advertising letter.' This close link between calligraphy and typography has persisted in Europe where centres of printing are more widely spread than in England and where there is a closer relationship between art schools, printing houses and the workshops of craftsmen. The same bond did not exist in England, a cause for regret.

One figure who dominates the history of German calligraphy is Rudolf Koch of Offenbach, who was born in 1874 and died in 1934. He was a skilled calligrapher and type designer and an inspiring teacher. He studied in Nuremberg, Hanau, Munich and Leipzig which were at that time the most important printing centres in Germany. He worked for the Klingspor type foundry in Offenbach and taught lettering at the School of Arts and Crafts there. His students and their work were of profound importance to

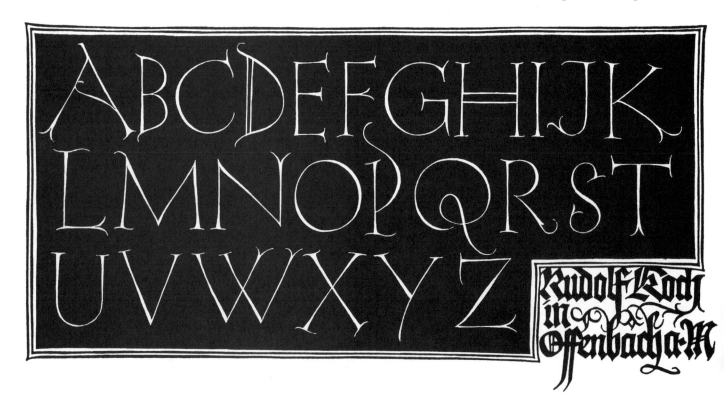

him and his teaching helped the development of his many talents. He re-established a close relationship between printing and penmanship and the most impressive part of his creative work were his type designs. He believed that no serious calligrapher can afford to overlook the making of manuscript books, for only there will he find all the questions and only there can he prove his art in answering them. As a calligrapher, Koch was at his best and most inventive in the decorative patterning of Gothic forms of letter. He used black-letter, for example, in a vigorous personal way that gave the writing a rich texture on the page with closely-packed lines of script, which led to very fine type designs based on his calligraphy.

In 1918 the group of Offenbach Penmen was organised and later developed into the Workshop Community where Koch and his assistants produced together many important works: lettering, woodcuts, tapestries, embroideries, block-books printed on Japanese paper, and metalwork. These were the products of a whole group of like-minded craftsmen working together with their remarkably versatile and inspiring master. His deeply religious feeling permeated all his work with a sense of dedication, a striving for quality and meaning in whatever he produced with his team.

All Koch's assistants had one thing in common, whatever their other skills might be, and that was a fundamental training in lettering. Many of his students made distinguished reputations as teachers and craft workers, among them being Henri Friedlander and Friedrich Henrichsen, both of them calligraphers; Fritz Kredel, wood engraver and illustrator; Warren Chappell, book designer and illustrator; Berthold Wolpe, who trained as a silversmith and became a distinguished book designer in London.

Other important workers in the field of calligraphy and related activities deserve mention. Jan Tschichold, Hon. R.D.I., for instance, who died in 1975, exerted a widespread influence on book design in Europe and America. His obiturist in *The Times* said of him that 'he came to books and type design from calligraphy, which he began to teach at the precocious age of eighteen and to which he gave a lifetime's study and affection.' Born

Schaff das Tagwerk meiner Hände / hohes Glück, daß ichs vollende · Laß, o laß mich nicht ermatten · Nein / es sind nicht leere Träume · Jetzt nur Stangen / diese Bäume geben einst noch Frucht und Schatten ·

BILD 21

Schaffe in mir, Gott, ein reines Herze, und gib mir einen neuen, gewissen Geist. Verwirf mich nicht von deinem Angesicht und nimm deinen heiligen Geist nicht von mir ·

Right
Rudolf Koch
A Gothic hand more freely written than the example in *Das Schreibbüchlein*.

Left
Rudolf Koch
From *Das Schreibbüchlein*, an introduction to writing, with woodcuts by Fritz Kredel. Decorative elements used as space filling. 7″ × 5½″ (18 × 14 cm). 1935

Opposite page
Rudolf Koch
Design from *The Little ABC Book of Rudolf Koch*, 1976, a facsimile of *Das ABC Büchlein*, published by Insel Verlag in 1934.

in Leipzig early in the century he studied at the Akademie für Graphische und Buchgewerbe in Leipzig and Dresden, and later taught lettering and typography in Munich. Among his many publications are *Geschichte der Schrift in Bildern*, published in England in 1946 as *An Illustrated History of Writing and Lettering* and his *Meisterbuch der Schrift* (*Sourcebook of Writing*) published in 1952.

Walter Kaech, who died in Zurich in 1970, acquired an international reputation as a calligrapher and he taught lettering for many years. He produced comprehensive books on calligraphy, lettering and typography, among them *Schriften* published in 1947, and *Rhythm and Proportion in Lettering* which appeared in 1956.

Imre Reiner studied graphic art under Ernst Schneidler in Stuttgart and is well known for his lively calligraphic inventions and type designs. Max Caflisch studied with both Jan Tschichold and Imre Reiner and later lectured on calligraphy and typography in Basle at the Allegemeine Gewerbeschule.

Hermann Zapf who was born in 1918, enjoys a legendary reputation as calligrapher, book designer and typographer. His wife, Gudrun Zapf von Hesse, is distinguished in the same field. He was influenced early by the books of Edward Johnston and Rudolf Koch, and his own books *Feder und Stichel* (Pen and Graver) and *Creative Calligraphy* (recently produced for Koh-I-Noor) have been important influences on calligraphers. His sheer versatility allied to quality is itself an inspiration.

BREVIS ESSE LABORO

Ich bemühe mich kurz zu sein

Horaz

Kleine Schlemmerei

HEINE
The Tragic
Satirist
—
PRAWER

HEINE
The Tragic
Satirist

A STUDY OF
THE LATER POETRY
1827–56

CAMBRIDGE

BY S. S. PRAWER

Friedrich Poppl, born in 1923 and died in 1982, became a Member of the Arts and Crafts School at Wiesbaden and subsequently Professor at the Technical College there. He specialised in designing alphabets for typesetting and photoprinting, extending the frontiers of calligraphic influence further than before. Like many European designers he held that 'Calligraphy will always remain the starting point for script design.' The examples of his work illustrated here show a superb sense of spacing and his more exuberant styles a refreshing vitality. His students include Gottfried Pott, a German calligrapher from Wiesbaden, who also studied with Werner Schneider and Karlgeorg Hoefer, and who has said 'It is our goal to maintain contact with great writing tradition and at the same time to realize new impulses of our time.' His spirited work also stresses form and structure. Fortunately in some German cities such inspiration for the development of calligraphy has kept flowing from master to pupil since the early years of the century.

GOD
has given
to each of us
a spirit with
wings on
which to soar
into the spacious
firmament
of Love
and Freedom.

Kahlil Gibran

*when walking
just walk,
when sitting
just sit,
above all,
don't wobble.*

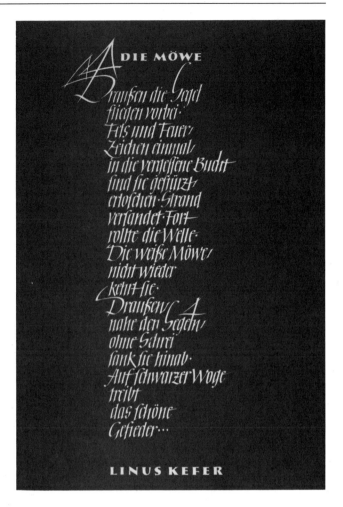

Above left
Karlgeorg Hoefer
'When walking, just walk..', a Chinese
saying. Written with a Japanese brush and
stick ink on Japanese paper. (A calligrapher
asleep in his boat.) 77 × 57 cm
(30″ × 22¼″). 1985

Above right
Friedrich Neugebauer
Linus Kefer, poem from an anthology.
23 × 14.5 cm (9″ × 5¾″). 1967

Below left
Karlgeorg Hoefer
'Christ ist Erstanden'. Written for
Contemporary Calligraphy, an exhibition
arranged by the Circulation Department of
the Victoria and Albert Museum, London,
1966 (Exhibit Circ.170, 1966.)

Opposite page
Hermann Zapf
A quotation from Kahlil Gabran. Original
design on rough-textured paper, later used
for silkscreen printing. 56 × 40.6 cm
(21¾″ × 15¾″). 1969

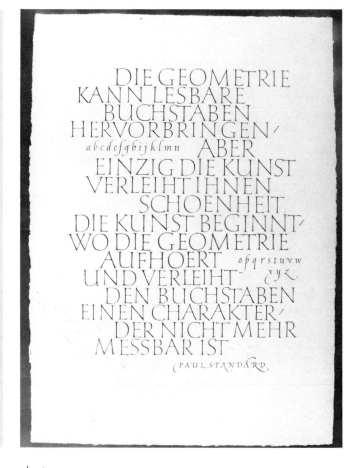

WRITING IT IS
THIS BOON TO
MANKIND THAT
ABRAHAM LINCOLN
PRAISED IN THE
HIGHEST OF TERMS
WHEN HE SPOKE
OF WRITING AS
THE GREATEST
INVENTION OF
MAN·

E·A·LOWE

Above
Hermann Zapf
Writing. Quotation from E A Lowe.
Broadside written in an interpretation of
capitalis quadrata. Black ink on cream paper
(name in red). 40 × 30 cm ($15\frac{1}{2}'' \times 11\frac{3}{4}''$).
1964
(Made for Mark Lansburgh, California.)

Above right
Werner Schneider
Die Geometrie by Paul Standard. Written
with a Hiero note-pen and stick ink on
Fabriano Roma handmade paper.
66 × 49 cm ($25\frac{3}{4}'' \times 19''$). 1985

Bottom right
Pamela Stokes
Extract from Hokusai's concluding remarks
to *100 Views of Fuji*. Broadsheet, written on
greyish-green Ingres paper. 42 × 38 cm,
text area 21.5 × 16.5 cm ($8\frac{1}{2}'' \times 6\frac{1}{2}''$). 1986

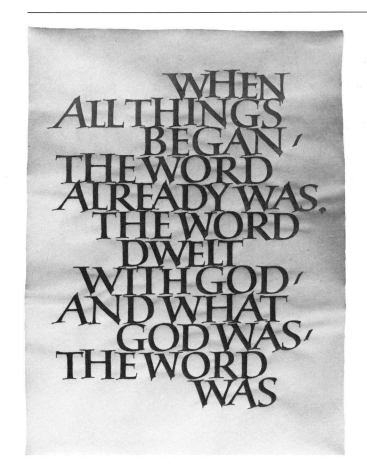

Werner Schneider
When All Things Began. Written with a
wooden stick and watercolour on Ingres
paper. 58 × 42 cm (22¼″ × 16½″). 1986

Below left
Max Waibel
The Birth of Christ. Extracts from the gospel
accounts of Saints Luke, John and Matthew.
Reduced in size.
Victoria and Albert Museum, London,
Circ. 166. 1966

Below
Friedrich Neugebauer
Pater Noster. Broadside on handmade paper.
36 × 24 cm (14″ × 9¼″). 1962

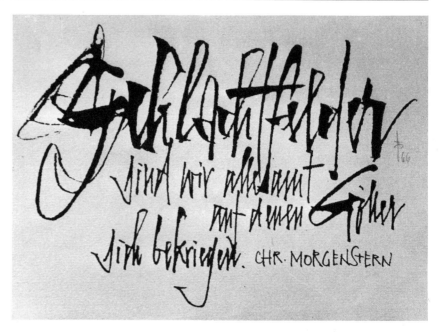

Right
Friedrich Poppl
Freehand brushwriting in which the
speed of movement is clearly
demonstrated. 1966

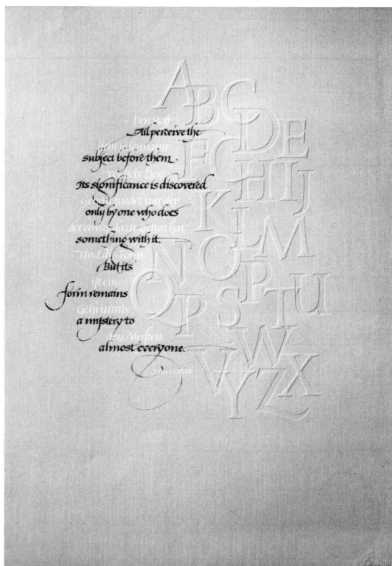

Right
Gottfried Pott
Quotation from Goethe. Writen with a
pen in black and white gouache on
Fabriano Roma paper. Alphabet
embossed. 66.5 × 48.5 cm. (26″ × 19″)
1986

Opposite page
Werner Schneider
Kein Enziger Bestandrell. Written with a
metal Redis pen and Indian ink on Ingres
paper. 58 × 42 cm (22¼″ × 16½″). 1985

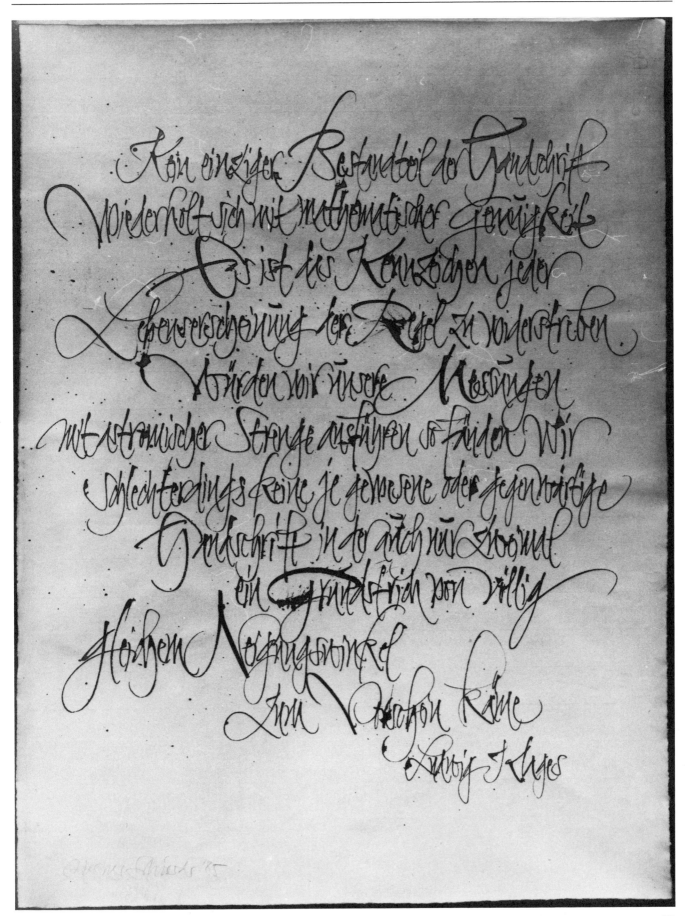

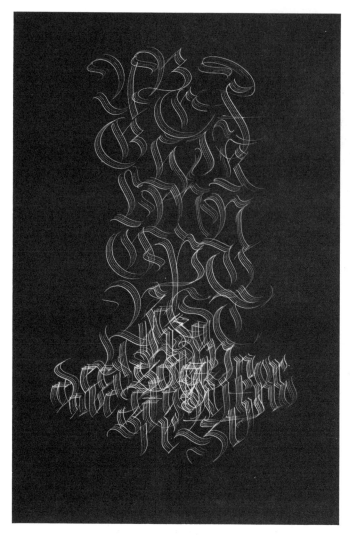

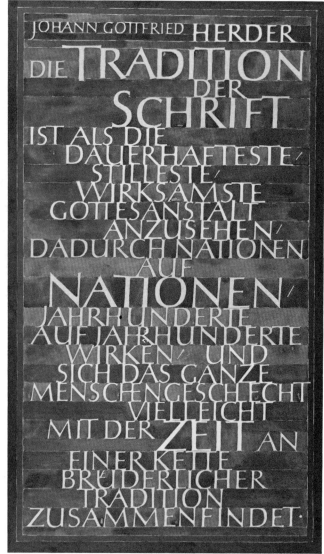

Above
Gottfried Pott
Fraktur alphabet written on glossy black
paper (Chromolux) in white gouache.
59 × 49 cm. (23″ × 19″) 1982

Above right
Hermann Zapf
Design for a tapestry, later woven by Inge
Richter, Offenback (180 × 108 cm,
$70\frac{1}{4}″ × 42″$).' Design 62 × 47 cm
($24\frac{1}{4}″ × 18\frac{1}{4}″$). 1974
(Made for Sigfred Taubert, Frankfurt.)

Centre
Eugen Kuhn
Title for a periodical, 1945

Bottom
Eugen Kuhn
Greeting card. 9.5 × 21 cm ($3\frac{3}{4}″ × 8″$). 1945

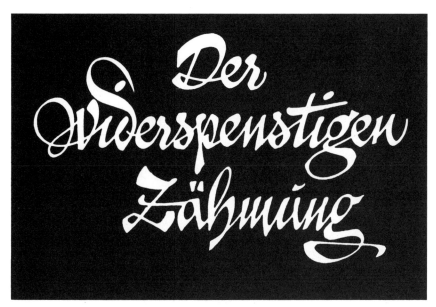

Pamela Stokes
Television credit card: *The Taming of the Shrew*. Original 30 × 40 cm ($11\frac{1}{2}''$ × $15\frac{1}{2}''$).
Late 1960s

Eugen Kuhn
Book plate.

Czechoslovakia

In Czechoslovakia the art of lettering has been associated with one outstanding personality Oldřich Menhart of Prague, who was born in 1897 and died in 1962. He was descended from a line of craftsmen and his early training made him a master of the pen and graver. As a book artist he successfully combined calligraphy, lettering, typography and type design. He absorbed the heritage of Western scripts and disciplined his hand by arduous practice. His penmanship is vigorous and his letterforms are ruggedly strong. He held that a good type cannot be designed until it has been written, and the pen has been the inspiration of many of his own type designs. One of Menhart's most remarkable works was the transcription of *Kytice*, a Czech classic, as a manuscript of 150 pages, which was illustrated by Antonin Prochazka and reproduced in facsimile. The lettering Menhart used for this book subsequently became his Manuscript type, in both roman and italic forms. He said of his Uncial type which appeared in 1949, that it was the result of twenty-six years of study.

Oldřich Menhart
Monograms. 1954

Netherlands

In the Netherlands Jan van Krimpen, who lived from 1892 to 1958, designed some of the most notable typefaces of this century and as a type designer, calligrapher and book artist was one of the great masters. His italic types were based on Renaissance scripts, which he also used as the basis of his own handwriting. The success of his typefaces, chiefly designed for the firm of Joh. Enschede en Zonen, brought him requests for lettering of many kinds – written, painted and engraved. He transcribed a number of manuscripts on vellum for his own pleasure and his formal calligraphy included work presented to royalty. The Dutch were fortunate in having a far-sighted craftsman with the skill and wide vision that Jan van Krimpen brought to the design of type at the time when their traditional Gothic forms were being displaced by roman and italic founts.

In association with Bruce Engelhart, Chris Brand, also a calligrapher and typographer, has done a great deal to encourage fine writing in the Netherlands. In the 1950s he produced a series of delightful booklets, *Ritmisch Schrijven* (Writing Rhythmically), as a method for primary schools.

Gerrit Noordzij of the Netherlands, when asked for the loan of work to appear in an earlier version of this book, replied 'Handwriting is my most important source of type design and typography. I allow myself absolute freedom, because such writing has no other purpose than my own flexibility.' His contribution to *Dossier A–Z 73* was particularly thought-provoking on the subject of teaching letterforms. This *Dossier* was the fruit of the Congress held in 1973 by the Association Typographique Internationale. It contained contributions by calligraphers, typographers and graphic designers, all of whom had expert opinions to express.

Jan van Krimpen
Monogram for J Brandt & Zoon.

Jan van Krimpen
Page from an unfinished manuscript. Written in black ink, with heading in blue, open initial and beginning of second paragraph in red. 12″ × 9½″ (30.5 × 24 cm). (By courtesy of S L Hartz.)

Gerrit Noordzij
A Dutch cursive hand demonstrating the mannerist trick of twisting the pen which was characteristic of 17th-century Dutch calligraphy. Note that it was written with a broad pen, not with a pointed pen as generally supposed for this handwriting technique. Reproduced the original size of the writing in *De Streek* by Gerrit Noordzij, 1985

Chris Brand
Monogram.

Chris Brand
Monogram for a publisher.

Chris Brand
Book jacket. Printed in one colour.

Lucas 24

29 {
mane nobiscum
quoniam
advesperascit et
inclinata
est iam dies.
}

32 {
nonne cor nostrum
ardens erat in nobis
dum loqueretur in
via et aperiret nobis
scripturas.
}

Chris Brand
Book jacket. Lettering in blue and black
on a grey background.

Gerrit Noordzij
'The pointed flexible nib is a difficult tool, the writing inclines to decadency because
the complicated technique lacks the reliable control of the broad nib. It explains the
background of John Baskerville and his successors, Bodoni, Martin, Didot and others,
making clear there could not have existed an influence of copper engraving on this
writing technique.' Reproduced the original size of the writing in *De Streek* by Gerrit
Noordzij, 1985

Scandinavia

A further valuable contribution to the literature of calligraphy is the survey of *Lettering and Printing Types* by Erik Lindegren of Sweden *EN ABC–BOK* published in 1975.

In Denmark Bent Rohde, with his book *Bredpenkursiv* (*Broad Pen Cursive*), influenced many students towards good letterforms. He also translated and transcribed into Danish Arrighi's *La Operina* and his own work deserves attention for his fine italic scripts.

Estonia

The exhilarating work of Villu Toots illustrated in this edition is of particular interest as an example of lettering from one of the Soviet Socialist Republics. Toots explains that Estonia, where he was born in 1916, has a language very different from Russian and an entirely independent cultural life, although of course it has felt the intellectual influence of immediate neighbours, such as the Germans, the Scandinavians and the Russians.

Villu Toots trained as a graphic designer, and this led on to his work as art director of a Tallinn publishing house, calligrapher and book artist. He founded the Lettering Art School in 1965 and has been responsible for lettering exhibitions and symposia. His many books are not easily available in the West and have not yet been translated into English. His personal contribution to this book is a delightful description of his philosophy for a life spent with lettering.

Bent Rohde
Book plate

Above
Villu Toots
Jubilee symbol. Written with Brause broad pen. 17 × 10 cm (6½″ × 4″).

Right
Villu Toots
Book plates.

Above
Ly Lestberg
Personal device for a letter heading. Miss Lestberg is a student of Villu Toots in Estonia.

Villu Toots
Experimental study. Written in white
gouache with a Brause broad pen on black
paper. 42.8 × 16.2 cm ($16\frac{1}{2}''$ × $6\frac{1}{4}''$).

Yugoslavia

The young calligrapher Jovica Veljović from Yugoslavia is also a type designer and he sees a relationship akin to a marriage between these two skills. In his country he is unusual in being an enthusiast for lettering. Inspired as a student by Hermann Zapf's book *About Alphabets* he has gone on to develop a gift for calligraphy of rare vitality and grace. He teaches his subject but finds it uphill work to involve his students in a skill that has as yet few financial outlets there.

The scene in Europe shows that a living tradition of calligraphic practice and teaching is by no means universal even within the countries of the EEC. We have few illustrations from French or Italian scribes for instance.

In those countries with a calligraphic continuum of achievement, and of innovation in the related fields of lettering, typography and book design, calligraphy attracts artistic talent and becomes itself an art form, as is seen in the outstanding work of Karlgeorg Hoefer, Friedrich Neugebauer, Max Waibel and others whose penmanship is illustrated here. These are master letterers experimenting with the pattern and expression of words, using them as shapes in unconventional ways. Letters are conceived as a medium, their colour, form and texture as parts of an exhilarating design which may become either an abstract art, or as a moving message enhanced by its beauty of structure.

In the last ten years the masterly influence of Austrian and German calligraphers has been felt in the USA especially their 'passion for excellence.' The effects of exhibitions such as those of the Zapfs and of Friedrich Neugebauer during the eighties, and the development of intensive workshops and resultant meetings of craftsmen, have enabled gifted teachers to kindle an enduring enthusiasm and convey a skill out of all proportion to the time spent in America.

Jovica Veljović
Quotation from the *Song of Solomon*.
35 × 25 cm (13¾″ × 9¾″). 1985

Jovica Veljović
Sentimentalities. 13 × 18 cm (5″ × 7″). 1980

Adrian Frutiger
Page from *Lettering: the development of European letter types carved in wood*, showing Rotunda (Round Gothic) of 15th century. Page size 11″ × 5⅞″ (28 × 15 cm). 1951

Lettering as an Art

Villu Toots

This distinguished Estonian book artist and calligrapher celebrated his seventieth birthday in 1986 with a notable exhibition. The astonishing range of his work has become well known to Western calligraphers through reproductions in books and journals.

In his own country he has been outstanding as a teacher and exponent of lettering throughout his career and there are now several hundred graduates from the lettering school he founded in 1965, including his own grandchildren. Although his books have not yet been published in English translation the wit and exuberance of his more innovative examples need no explanations. In his early years a student of Edward Johnston's manual he is master of the many traditional forms required of a book artist with a wide practice.

The illustrations of his work included here show a lively and progressive outlook, as he says himself . . . 'the new calligraphic ballet is more swingful and spontaneous'. The essay on his philosophy as an artist with a lifetime of dedication to lettering is a welcome addition to this present book.

I belong to those who enjoy making letters and designing lettering, the aesthetic impact of which goes beyond their communicative value. In Estonian, my native language, one and the same word stands for both 'star' and 'letter'. Thus I have been a star-gazer throughout my conscious life, and letters have been my guiding stars in the choice of my craft and profession. Ever since my schooldays I have been contemplating letters *with my own eyes*, and making letters *at my own will*. The noble ancient art of lettering has become my life, my work, and it fills leisure hours.

Script is language made visible and thought rendered readable. Of course, the first requirement any script must fulfil is sound legibility, but sometimes one should remember that the difference between utilitarian script and decorative lettering is the same as the difference between the idiom of the marketplace and the language of literature.

The art of lettering has passed through the same stages as figurative art and architecture. Scribes lost their job long ago, but the printing press has never been able to compete with the individual character and unrepeatable charm of a written text – a machine is only capable of reproduction. We are surrounded by letters to such an extent that reading has become as automatic as breathing. For that reason we become conscious of the form of the letter or of its aesthetic function only if there is something to arrest attention. The task of the contemporary artist is to create emotions that activate the inner life.

The touchstone is command of penmanship without which it is impossible to produce good lettering or design letters for printing. It is proficiency in broad-nib lettering that opens the door to great art. This tool contributed to the development of the majority of styles in lettering, to the structure and proportions of letters, and to the placing of the fine or thick lines. The sensitive pen offers a great variety of possibilities, but it is also demanding. In a master's hand it lends an individual touch to the work of imagination, and at the same time it provides a logical foundation without which lettering would lack in rhythm or character. In addition, all lettering must reflect not only the character of the writer, but also the nature of the tool and material, be it a broad or a script-nib, a brush, or be the letters cut into linoleum or wood, incised into stone or metal, woven into textile, engraved in glass, or modelled in leather. A learner of calligraphy must observe the rules painstakingly, for the broad nib will control his hand and prevent him from committing errors. It is only a skilled master who may take liberties – his creative intelligence will subject the rules to his will. With a skilled letterer everything depends on the degree of his virtuosity, on his talent and ingenuity. Beautiful calligraphy, however, can be achieved only if he puts all his heart into the writing.

A calligrapher will always comply with the taste and spirit of his own times. The text conditions the style, the approach, and the composition which, in turn, determine the rhythm and contrast, the whole creative logic, upon which all the sentences, words and letters must be based. Gianbattista Bodoni, the king of printers and the printer of kings, wrote in the eighteenth century: 'Letters can possess charm only when written with delight and love.'

Not every pen or every brush is fit for writing, not

every letterer will make an artist. There will always be more honest tradesmen than creative spirits.

Every innovation begins with an experiment, but every experiment cannot be considered an innovation – it is only the raw material needed for the birth of a novelty. Innovation and tradition represent two contrary poles, and yet they supplement one another. Lettering that lacks tradition, or does not honour it, is seldom mature craftsmanship, and it will cease to develop as any art that does not search for new forms of expression. Every artist with a broad view must also look into the past for a sound interpretation, because the history of lettering is much more closely connected with the present than, say, the steam engine is with the jet.

Goethe and Schweitzer have compared architecture with music turned to stone. Good calligraphy likewise has a singing quality, its movement shows elegance, and to my mind one is justified in calling calligraphy a ballet of letters. In the same way as there is classical and modern ballet there is also traditional eighteenth-century and nineteenth-century calligraphy and that of the present. In order to make the latter, one must have a command of the former. Calligraphy is dynamics. Since, in our writing, the movement of the hand and of the eyes occurs to the right, the slanting form of the calligraphy seems to be more natural and more dynamic than an upright one.

Oriental calligraphy is very beautiful. It is connected with aesthetic and religious concepts, and constitutes an integral part of Oriental art proper. The hieroglyphics and drawing are at times so interrelated that they fuse into an integral whole. Reeds in the wind, hieroglyphics, water flowing over stones, hieroglyphics again – this is all rendered with such spontaneity and enviable mobility that it is difficult to decide where one of the elements of this pattern ends and another begins. At times the stroke of a brush moves like lightning, at others it pulsates nervously, and in the next instant it becomes tame and contemplative, only to move in elegant loops at the very next moment. Sometimes the brush is screwed up to a hair-thin point, and sometimes it is pressed down fan-wise. Tension can be felt in every line, be it drawn with a brush full of ink or with a half-dry one.

Some Western calligraphers have tried to become skilled in Oriental brushwork but few of them have succeeded in achieving a synthesis of rhythm and swing. Our letters are too simple for obtaining interesting and picturesque form with the help of playful lines. My friend Karlgeorg Hoefer sketched once the following words on a sheet of paper: 'The brush dances, and the ink sings.' This joyful thought, as profound as an Oriental aphorism, expresses laconically the great emotional surge of an artist.

Villu Toots
Written with Brause ATO pen on watercolour paper.
14 × 20 cm (5½″ × 7¾″).

93

Contemporary abstract calligraphy, sometimes called experimental calligraphy, and also called calligraphy without words, was evidently inspired by Oriental brush calligraphy. In such calligraphy there are no decipherable letters or words, there are only strokes of brush or pen, made in a surge of inspiration. And if there are any letters at all, they only serve as decorative elements, as a means of artistic expression. We contemplate that nonscriptual picture in the same way as we look at a nonfigural work of art. Every kind of collage is possible here; letters and words of every size and style, criss-cross, fused with the background and with each other.

The first good book that I was able to acquire was *Lettering of Today*, published by Studio, 1937. Its study meant a turning-point for me: a self-taught letterer, I started to revise my work and my principles. I was greatly attracted by the work of Edward Johnston, the pioneer of contemporary calligraphy, and his school; I hold him in high esteem at present as well, though now I consider myself a representative of the more liberal wing of his school. In 1963 my work appeared for the first time in *Calligraphy Today*, Studio, and the following year in *Lettering Today*, Studio Vista, 1964. Twelve years later, the Society of Scribes and Illuminators, founded in recognition of Edward Johnston's teaching, elected me an Honorary Member (the ninth in number) on the occasion of the Society's fiftieth anniversary.

As the illustrations show, my calligraphy is free and impulsive enough, sometimes even moving on the border of abstraction. The graphic line is not always pure and elaborate, but spontaneous, sketchy and brittle. I prefer writing on coarse-grained paper, using a quill or a brush – on the whole, I favour a supple tool. Paul Freeman called my play of lines choreographical calligraphy.

The book is my best friend, and my favourite work is the making of a book. I have designed over six hundred publications, mostly with the help of lettering. A book is made more valuable by an Ex-libris – I have made many of those as well, again with the help of lettering, the total amounting to circa three hundred. I enjoy writing formal addresses, posters and congratulatory cards. I am happiest, however, when producing calligraphical designs and studies. You will realize that not everything written by me is meant for reading – some of it is intended just to be looked at.

Lettering is my music, wandering with my pen along untrodden paths, calligraphcal meditation. For long years now I have been in the thrall of that power which is hidden in letters. It has taken complete command of me; it is my work and my leisure.

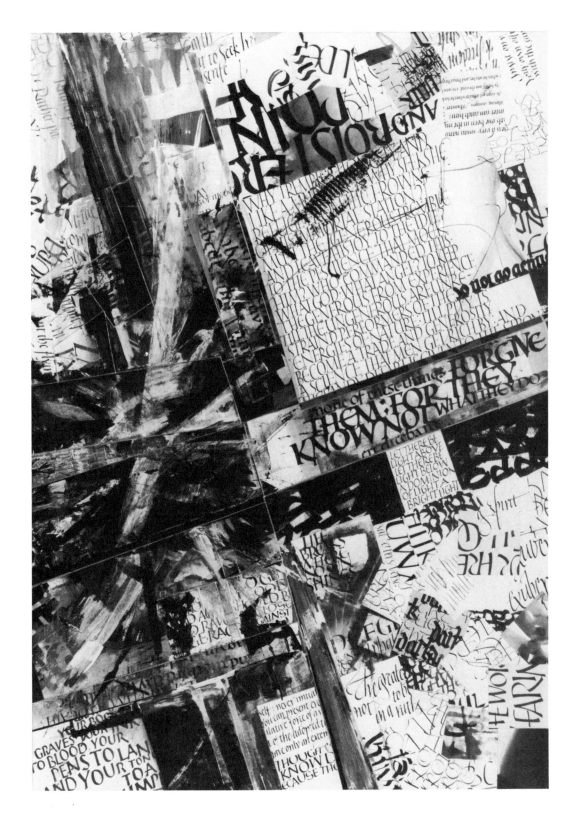

Calligraphy in the USA

W A Dwiggins
Book label

W A Dwiggins
Book label

Previous page
Thomas Ingmire
'Forgive them' collage, with texts from a variety of sources: the Bible, Shakespeare, William Blake, Dylan Thomas. Made for the Nuclear Disarmament and World Peace Exhibition, San Francisco. Ink, gouache, watercolour, acrylic, gold leaf and powder. 24″ × 17″ (61 × 43 cm). 1986

In a country as vast as the USA it is not surprising that the growth of interest in penmanship this century emerged and flourished around the teaching and influence of distinguished calligraphers, in centres as far apart as New York, Rhode Island, Chicago, Portland, Oregon and later in California.

In the early years of the century attempts to reform handwriting, lettering and type design were made by such men as Frederic W Goudy, 1865–1945, Bruce Rogers, 1870–1957, William A Dwiggins, 1880–1956, Warren Chappell and T M Cleland. However, less beneficial influences – the Spencerian copybooks and the Palmer method of business writing – held penmanship in their mechanical grip well into the twentieth century.

William Addison Dwiggins had a wide-ranging talent for lettering, illustration and type design that was unique in the graphic arts of America. As early as 1907 he suggested to Goudy that they should form a calligraphic society – but in vain. By 1925 he had created a purely imaginary 'Society of Calligraphers' and issued handsome certificates of honorary membership to twenty-two people in the fields of publishing and the graphic arts. As a calligrapher he used both a formal and a semi-formal hand, at first in advertising and then in book production. His work for typography was outstanding and for thirty years he designed books for Alfred A Knopf, the New York publishers. His calligraphy owes little to European sources and has a gaiety and originality entirely his own. Philip Hofer, curator of the Printing and Graphic Arts Department in Harvard College Library, said in 1935 that the revival of interest in the art of calligraphy was in large measure due to Dwiggins: 'In it he stands head and shoulders above any other American designer – as individual in his style as he is accomplished and imaginative.'

One of the earliest exponents of formal penmanship was Ernst Frederick Detterer of Chicago. He came to England in 1913 and had private lessons with Edward Johnston. He played a significant part in the development of the calligraphic tradition, particularly in the Mid-West, by his teaching and practice of the craft. He encouraged such distinguished scribes as James Hayes and Raymond DaBoll to broaden and extend their use of calligraphy. In 1931 Detterer became curator of the John M. Wing Foundation of the Newberry Library in Chicago, which holds an outstanding collection of calligraphic material, including works by early European writing masters.

Using as a focus the material in the Library's collection, Detterer founded the Newberry Library 'Calligraphy Study Group' which became a potent influence in the American development and many practitioners can trace their inspiration to this source. The Study Group was carried on after Detterer's death by James Hayes and James M Wells, who himself became curator of the Wing Foundation in 1951.

A versatile calligrapher was John Howard Benson, who lived and worked in Newport, Rhode Island, where he was born in 1901 and died in 1956. Johnston's manual inspired in Benson so strong a desire to create beautiful letters that his whole life became directed to that end. He studied in New York at the National Academy of Design at a time when lettering had no recognised place in art education. He was attracted by typography, but a happy chance changed the direction of his work and he turned to cutting letters of beauty and distinction in stone. In 1950, together with his partner Graham Carey, Benson published a manual for students entitled *Elements of Lettering*. He acquired an Arrighi manual of 1554, *La Operina*, and having mastered the italic hand himself, translated and transcribed his version for facsimile publication in 1954. This work was an immediate inspiration and brought him many friends.

ARTICLE I

THE *Society of Calligraph-ers exists to stimulate inter-est in the production of Fine Printing; to foster the appre-ciation of the graphic arts allied with printing; and, particularly, to contrib-ute toward maintaining the dignity of the char-acters of the alphabet.*

ARTICLE XVI
Section 1 IT *is proper for the Society to choose persons who are distinguished for their accomplishment in the Arts, and to elect them Honorary Members of the Society.*

Section 2 CANDIDATES *for Honorary Membership are to be proposed by the Board of Regents only.*

Section 3 HONORARY *Members may be elected at any reg-ular business meeting by members present.*

Section 4 AN *Honorary Member shall enjoy all the privileg-es of membership, and in addition may receive gra-tuitously the publications of the Society.*

Section 5 AN *Honorary Member is exempted from the pay-ment of an entrance fee, and from all dues.*

The Honorary Members of the Society:

GEORGE G. ADOMEIT
BEATRICE L. BECKER
JOHN BIANCHI
EDGAR SUMNER BLISS
HENRY LEWIS BULLEN
EARNEST ELMO CALKINS
THOMAS MAITLAND CLELAND
OSWALD BRUCE COOPER
JOHN COTTON DANA
FREDERIC W. GOUDY
CHARLES HOPKINSON
HENRY LEWIS JOHNSON
ALFRED A. KNOPF
HENRY W. KENT
STANLEY MORISON
CARL PURINGTON ROLLINS
BRUCE ROGERS
RUDOLPH RUZICKA
HENRY H. TAYLOR
DANIEL BERKELEY UPDIKE
FRANK WEITENKAMPF
GEORGE PARKER WINSHIP

BOSTON *May* 11th 1925

W A Dwiggins
Society of Calligraphers: articles and list of honorary members 11 May, 1925.
Handwritten and printed in black on Japanese paper. $7\frac{5}{8}'' \times 10\frac{3}{8}''$ (19.5 × 26.5 cm).

W A Dwiggins
Chapter heading for an Alfred A Knopf publication.

Above
Ernst Detterer
Quotation from 'The Art of the People', an essay by William Morris. Written in red and black ink. Page size $11\frac{1}{4}'' \times 9''$ (28.5 × 23 cm). 1917 (By courtesy of James Hayes.)

Right
Raymond F DaBoll
Title page for a book by Paul Standard. The title and cross in red. $9\frac{1}{4}'' \times 5\frac{7}{8}''$ (23.5 × 15 cm). 1947

WITH HINTS
FOR ITS WIDER USE
TODAY

By Paul Standard

✝

THE SOCIETY OF TYPOGRAPHIC ARTS
CHICAGO · 1947

James Hayes
Book labels

James Hayes
Diploma. Written black on pale cream, top line warm brown, stars and seal gold. 8½″ × 11″ (21.5 × 28 cm). 1975

Arnold Bank, an influential calligrapher and teacher, born in New York in 1908, trained there and then taught in many of the principal schools in the New York area. As a Fulbright Senior Lecturer in the Lettering Arts, he is remembered in England for his inspiring teaching and his dynamic lettering demonstrations at the Royal College of Art in the 1950s – his own work being adventurous, full of colour and excitement.

Edward Karr, born in Connecticut in 1909, was influential as an instructor of calligraphy and lettering; he taught at the School of the Museum of Fine Arts in Boston for many years.

The interest in italic handwriting in America began in the first quarter of the century, Ernst Detterer was already teaching italic by 1924. In the same year Marjorie Wise, a teacher, published *The Technique of Manuscript Writing* which sold well for twenty years, and Frederic Warde contributed to the revival with a facsimile edition of Arrighi's two writing manuals, brought out in 1926.

Much credit is also due to Paul Standard, born in New York in 1896, and widely influential as a calligrapher and teacher. He long campaigned for a reform of handwriting in the schools based on Arrighi's italic script and derived English exemplars. For many years he taught at the Cooper Union Art School in New York. His modest and informative book *Calligraphy's Flowering, Decay, & Restauration* – a delight on the eye – came out in 1947. It was designed by Ray DaBoll and subsequently became a fruitful link between Hermann Zapf and the lettering and calligraphy movement in the USA.

In the north-west area the fine teaching of Professor Lloyd Reynolds, subsequently designated Calligrapher Laureate of Oregon, has been outstanding, Rick Cusick, writing in 1979, said: 'Lloyd Reynold's classes in calligraphy at Oregon's Reed College spearheaded a movement that has mushroomed across the country and is still growing.' Like many others Reynolds was early influenced by Johnston's manual; with the help of Arnold Bank and Alfred Fairbank he became a calligrapher and in his

Arnold Bank
Roman capitals interlaced with Phoenician script. Written on watercolour paper.
15½″ × 22″ (39.5 × 56 cm). 1966

Lloyd Reynolds
Book plates. Printed russet on cream paper
for the Michael Rubin Memorial Collection,
white on olive green paper for Esther Bowie
and 'A gift to the people of Sapporo'.

teaching always stressed the beauty and versatility of italic. The list of his
students who have become professional scribes is impressive and among
his publications *Italic Calligraphy and Handwriting*, 1969, should be noted.

In 1958 Lloyd Reynolds mounted an exhibition at the Portland Art
Museum with the title 'Calligraphy: The Golden Age and Its Modern
Revival.' It was the culmination of his years of research and study into the
historical styles of writing and the work shown ranged from the time of
Charlemagne to the present day. The exhibition demonstrated his convic-
tion that the tradition which produced such work is still a living force
underlying the modern revival. Such exhibitions have played an influential
part in the movement in America, as the excellent illustrated catalogues –
an extension of the exhibitions themselves – faithfully remind us.

In 1959 P W Filby mounted an exhibition of 'Calligraphy and Illumin-
ation' at the Peabody Institute Library, Baltimore, of which he was the
Assistant Director. Much of the material shown was the work of British
calligraphers, most of them members of the Society of Scribes and Illumi-
nators. This was followed in 1961 by another exhibition at the Peabody
Institute 'Calligraphy and Handwriting in America, 1710–1961', which
showed some of the history of the art, together with the work of many
American scribes from the time of Dwiggins and Detterer. The middle
years of the century were punctuated by these splendid exhibitions, which
were the forerunners of the magnificent tripartite showing in 1965, 'Two
Thousand Years of Calligraphy', organised by Dorothy Miner, Keeper of
Manuscripts at the Walters Art Gallery, Baltimore, Victor Carlson, Curator
of Prints and Drawings at the Baltimore Museum of Art, and P W Filby.
This exhibition illustrated the long historical background, traced the de-
velopments through the centuries and included some of the best work of
contemporary scribes. The scholarly and detailed catalogue remains a
valuable reference book for students.

¢ After watching
seagulls,
feeling my weight
in my shoes
again

¢ A warmer
winter afternoon:
the sleeping seeds
stir
then sleep again

696 PAGES $1.25
IN CANADA $1.45

THE PORTABLE
PLATO

THE MOST FAMOUS WORKS OF
THE MOST INFLUENTIAL MIND
IN WESTERN PHILOSOPHY.
PROTAGORAS
PHAEDO · SYMPOSIUM
THE REPUBLIC
ALL COMPLETE

EDITED, AND WITH AN
ILLUMINATING DISCUSSION OF
THE PLATONIC DIALOGUE, BY
SCOTT BUCHANAN

Salter

ABCDEFGHJ
KLMNOPQR
STUVWXYZI

HAVEHORSTDEMNQWX

Versal letters freely adapted from 12th century calligraphy with suggested stroke sequences & some related versal-alternates.

Lettering chart no. 8. Catfish Press, St. Ambrose College Davenport Iowa
1940

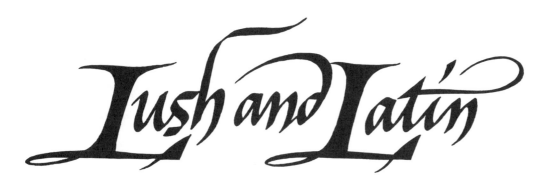

DEDICATED
TO THE MEMORY OF
THE NINETY BOYS OF THE HILL
WHO GAVE THEIR LIVES
SO THAT WE THE LIVING
MIGHT CONTINUE TO ENJOY THE BLESSINGS
OF FREEDOM AND DEMOCRACY

*— "So they gave their bodies to the commonwealth
and received, each for his own memory, praise that
will never die, and with it the grandest of all sepulchres,
not that in which their bones are laid, but a home
in the minds of men, where their glory remains fresh
to stir to speech or action as the occasion comes by.
For the whole earth is the sepulchre of famous men;
and their story is not graven on stone over their native
earth, but lives on far away, without visible symbol,
woven into the stuff of other men's lives. For you now
it remains to rival what they have done—"*

THUCYDIDES: Pericles' Oration to the Athenians: 430 B.C.

Above
Maury Nemoy
Album cover title for Capitol Records.

Below
Paul Standard
Dedication page from the memorial
volume for Hill School, Pottstown.
The original written in red and black.
$20\frac{1}{2}'' \times 15\frac{1}{4}''$ (52 × 39cm). 1951

OPPOSITE PAGE
Above left
Lloyd Reynolds
Weathergrams. Very brief pithy poems with
a Zen flavour to be hung out of doors on trees.

Above right
George Salter
Book jacket

Below
Edward M Catich
Alphabet of Versal Letters. No. 8 of a
series of charts made for the Catfish
Press. $11\frac{1}{4}'' \times 15''$ (28.5 × 38 cm).
1940

The LORD is my shepherd; I shall not want. He maketh me to lie down in green pastures: he leadeth me beside the still waters. He restoreth my soul: he leadeth me into the paths of righteousness for his name's sake.

Yea, though I walk through the valley of the shadow of death, I will fear no evil: for thou art with me; thy rod and thy staff they comfort me. Thou preparest a table before me in the presence of mine enemies: thou anointest my head with oil: my cup runneth over. Surely goodness and mercy shall follow me all the days of my life: and I will dwell in the house of the LORD for ever.

Three passions

simple but overwhelmingly strong have governed my life:

the longing for love,

I have sought LOVE first, because it brings ecstasy — ecstasy so great that I would often have sacrificed all the rest of my life for a few hours of this joy. I have sought it next, because it relieves loneliness — that terrible loneliness in which one shivering consciousness looks over the rim of the world into the cold unfathomable lifeless abyss. I have sought it finally, because in the union of love I have seen in a mystic miniature, the prefiguring vision of the heaven that saints and poets have imagined. This is what I have sought, and though it might seem too good for human life, this is what — at last — I have found.

the search for knowledge

With equal passion I have sought KNOWLEDGE. I have wished to understand the hearts of man. I have wished to know why the stars shine. And I have tried to apprehend the Pythagorean power by which number holds sway above the flux. A little of this, but not much, I have achieved.

and unbearable pity for the sufferings of mankind.

LOVE and KNOWLEDGE, so far as they were possible, led upward toward the heavens. But always PITY brought me back to earth. Echoes of cries of pain reverberate in my heart. children in famine, victims tortured by oppressors, helpless old people a hated burden to their sons, and the whole world of loneliness, poverty, and pain make a mockery of what human life should be. I long to alleviate the evil, but I cannot, and I too suffer.

These passions, like great winds, have blown me hither and thither; in a wayward course over a deep ocean of anguish, reaching to the very verge of despair.

This has been my life. I have found it worth living, and would gladly live it again if the chance were offered me.

BERTRAND RUSSELL

Maury Nemoy, 1974

It was primarily the formal and semi-formal italic hand that made headway in the USA. Italic became a model for teaching everyday handwriting and popular for amateurs and professionals alike, and this script has actually represented the word Calligraphy for many a student. Paul Standard, for instance, used it widely in his commissions and many inventive variations in commerce and the book arts were used by Ray DaBoll. His Festschrift, *With Respect ... to RFD*, compiled by Rick Cusick, gives a heartening insight into the fertilising influence of Ray DaBoll's generous friendships with other calligraphers and typographers not only in America, and the network of interest and support between likeminded artists.

The effort involved in converting teachers in schools to italic handwriting should not be underestimated – the teacher as well as the pupils has to be committed to learning and it is not surprising that schools were slow to adopt italic. The books of Fred Eager have been an impetus in this direction, his *Italic Way to Beautiful Writing*, 1974, itself a revision of his *Guide to Italic Handwriting*, is designed as a complete teaching course for children and adults. The foreword is by Sheila Waters who herself takes up the story of American calligraphy in her contribution to this book.

Although, as we have stressed, the strongest influence on American calligraphers and designers has been italic, it has been of particular interest to a British author to observe the upsurge of interest in formal historical scripts in certain centres.

The production of excellent periodicals by calligraphy societies in recent years, has informed a wider circle of interested people in the personalities and work of a variety of lettering and book artists from an international range. *Alphabet* as edited by John Prestianni for the Friends of Calligraphy in San Francisco, maintained a consistently high standard in the past decade. *The Scribe*, currently edited by Stan Knight for the Society of Scribes and Illuminators in Britain, has an international circulation. *Calligraphy Idea Exchange*, Associate Editor Michael Gullick, is a well-produced American quarterly magazine, in which the reproductions in colour are valuable at a time when lettering artists are exploring more adventurous excursions into the use of colour contrasts.

There is increasing evidence that scribes on both sides of the Atlantic are indeed approaching calligraphy as a new art form, using the wide range of tools and materials now available to bring brilliant and imaginative skill to the design of letters and the written page and even collaborating with computers in photo composition.

In America in this century works have been collected and commissioned by patrons with knowledge and perception such as Philip Hofer, Harvard University Library, Richard Harrison of California (whose fine collection of calligraphy and lettering is now in the San Francisco Public Library) and Guillermo Rodriguez-Benitz, whose patronage has stimulated the making of fine manuscripts.

Considered as a work of fine art, an example of calligraphy today will be judged as it were a drawing or a painting – for its inner life and its outward appearance and design. The heart of the matter is quality. We judge the writing of the past by our own standards of excellence, so will the products of our time be judged by future eyes. The work may be ephemeral in our terms, in projects such as bookjackets or advertisements, but the quality of the writing can still attain excellence. With a commission for a calligraphic work of some substance or even grandeur, it is even more obvious that it should be made to endure and be as fine as heart and hand can achieve.

Opposite page, above
Byron J Macdonald
Twenty-third Psalm. Written in black with initial in red. An illustration in his book, *The Art of Lettering with the Broad Pen*, shows the same design later used as a mural in the chapel of Stanford Hospital, California, length of lettering 60″ (152.5 cm). 1957 and 1961

Opposite page, below
Maury Nemoy
Quotations from Bertrand Russell. Variegated writing with a reed pen in colour and black on white paper. 20″ × 26″ (51 × 66 cm). 1974

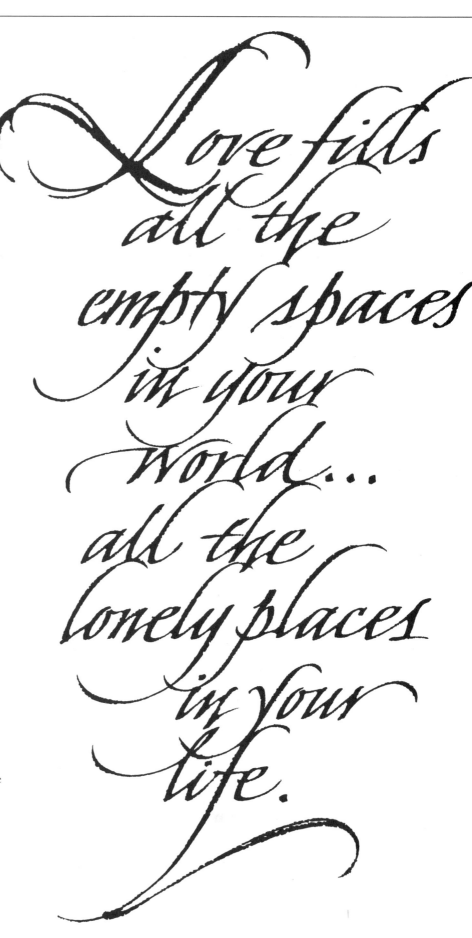

Rick Cusick
Quotation written out for an in-house
exhibit, the lettering to be etched in
magnesium.
(© Hallmark Cards, Inc.)

Opposite page
John Stevens
Axis: Bold as Love by J Hendrix.
Written with brush and pen on black
Ingres paper in purple and white.
23″ × 15″ (58.5 × 38 cm). 1985

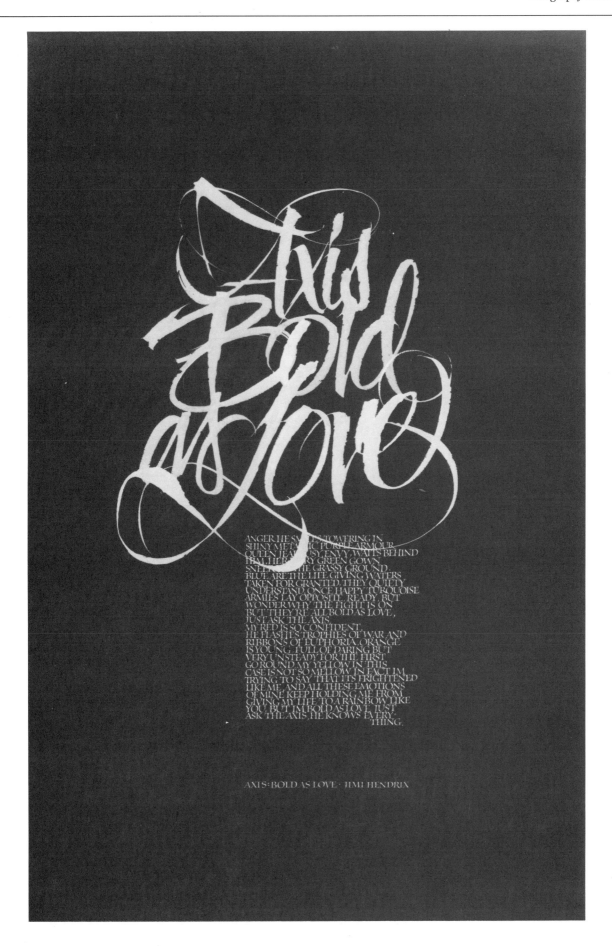

ANGER HE SMILES TOWERING IN
SHINY METALLIC PURPLE ARMOUR.
QUEEN JEALOUSY, ENVY, WAITS BEHIND
HIM, HER FIERY GREEN GOWN
SNEERS AT THE GRASSY GROUND.
BLUE ARE THE LIFE GIVING WATERS
TAKEN FOR GRANTED, THEY QUIETLY
UNDERSTAND. ONCE HAPPY TURQUOISE
ARMIES LAY OPPOSITE, READY, BUT
WONDER WHY THE FIGHT IS ON
BUT THEY'RE ALL BOLD AS LOVE,
JUST ASK THE AXIS.
MY RED IS SO CONFIDENT,
HE FLASHES TROPHIES OF WAR AND
RIBBONS OF EUPHORIA. ORANGE
IS YOUNG, FULL OF DARING BUT
VERY UNSTEADY FOR THE FIRST
GO ROUND. MY YELLOW IN THIS
CASE IS NOT SO MELLOW IN FACT IM
TRYING TO SAY THAT ITS FRIGHTENED
LIKE ME, AND ALL THESE EMOTIONS
OF MINE KEEP HOLDING ME FROM
GIVING MY LIFE TO A RAINBOW LIKE
YOU BUT IM BOLD AS LOVE, JUST
ASK THE AXIS, HE KNOWS EVERY-
 THING.

AXIS: BOLD AS LOVE · JIMI HENDRIX

18 March 1982

IT'S YOUR
BIRTHDAY
DEAR·DEAR·FRIEND
GLORY BE
WE ARE SINGING
GLORY
HALLELUJAH
AND FEELING
VERY NICELY
AND EVERYONE
IS CALLING
TO WISH US
HAPPY
BIRTHDAY

Sunday, 14 March 1982

LOVE TONS OF LOVE AND EVERY GOOD WISH ON THIS DAY & ALWAYS

Actually, I have been wanting to do something like this for you for ages

Actually this was a code statement Gertrude used to describe the long awaited American Occupation of Paris

BINSEY POPLARS felled 1879

ALL THAT MATTERS
IS THAT ONE
IS CREATED ANEW
Tender and true and all for you
AS GERTRUDE SAID

To quote St. Paul, the Apostle to the Gentiles...

Every day is a renewal, every morning the daily miracle. This joy you feel is life. e.e.

My aspens dear, whose airy cages quelled

BINSEY POPLARS

My aspens dear, whose airy cages quelled,
Quelled or quenched in leaves the leaping sun,
All felled, felled, are all felled:
Of a fresh and following folded rank
Not spared, not one
That dandled a sandalled
Shadow that swam or sank
On meadow and river and wind-wandering weed-
winding bank.

O if we but knew what we do
When we delve or hew—
Hack and rack the growing green!
Since country is so tender
To touch, her being so slender,
That, like this sleek and seeing ball
But a prick will make no eye at all,
Where we, even where we mean
To mend her we end her,
When we hew or delve:
After-comers cannot guess the beauty been.
Ten or twelve, only ten or twelve
Strokes of havoc únselve
The sweet especial scene,
Rural scene, a rural scene,
Sweet especial rural scene.

IT IS VERY ASTONISHING ABOUT BIRTHDAYS, SOME PEOPLE ARE BORN ON THEIR BIRTHDAYS AND SOME ARE NOT...

HAPPY BIRTHDAY MIRIAM

TO HAVE A BIRTHDAY OH MY... AND DARLING SAID ME TOO

ALL RIGHT HAVE ONE HAVE A BIRTHDAY DARLING

we're anything brighter than even the sun
(we're everything greater than books might mean)
we're everyanything more than believe
with a spin
leap alive we're alive
we're wonderful one times one

e.e.cummings

Le courage? il me semble
que cela consiste a affronter sans
crainte tous les obstacles quand
on desire ou veut quelque chose.

COURAGE? IT SEEMS TO ME THAT

THIS CONSISTS IN CONFRONT. WITHOUT

FEAR ALL OBSTACLES WHEN ONE

DESIRES OR WANTS SOMETHING

From a letter from Simone de Beauvoir to Immaculate Heart High School students. 1980.

Alastair & Barbara Nelson
request the pleasure
of your company
at a buffet luncheon
at 26 Malbrook Road
Putney sw 15
to celebrate
the marriage of
Jo-Ann Ranish
to
Terry O'Donnell
on Saturday
the 6th of September 1980
at 12:45 p.m.

R.S.V.P.
01-788-8444

Season of mists and mellow fruitfulness,
 close bosom-friend of the maturing sun;
conspiring with him how to load and bless
 with fruit the vines that round the thatch-eves run;
To bend with apples the moss'd cottage trees,
 And fill all fruit with ripeness to the core;
 To swell the gourd, and plump the hazel shells
With a sweet kernel; to set budding more,
 And still more, later flowers for the bees,
 Until they think warm days will never cease,
 For Summer has o'er-brimm'd their clammy cells.

Who hath not seen thee oft amid thy store?
 Sometimes whoever seeks abroad may find
Thee sitting careless on a granary floor,
 Thy hair soft-lifted by the winnowing wind;
Or on a half-reap'd furrow sound asleep,
 Drows'd with the fume of poppies, while thy hook
 Spares the next swath and all its twined flowers;
And sometimes like a gleaner thou dost keep
 Steady thy laden head across a brook;
 Or by a cyder-press, with patient look,
 Thou watchest the last oozings hours by hours.

Where are the songs of spring? Ay, where are they?
 Think not of them, thou hast thy music too—
While barred clouds bloom the soft-dying day,
 And touch the stubble-plains with rosy hue;
Then in a wailful choir the small gnats mourn
 Among the river shallows, borne aloft
 Or sinking as the light wind lives or dies;
And full-grown lambs loud bleat from hilly bourn;
 Hedge-crickets sing; and now with treble soft
 The red-breast whistles from a garden croft;
Keats And gathering swallows twitter in the skies.

IT IS A BEAUTEOUS EVENING, calm & free
The holy time is quiet as a nun
Breathless with adoration; the broad sun
Is sinking down in its tranquility
The gentleness of heaven broods o'er the sea:
Listen, the mighty Being is awake,
And doth with his eternal motion make
A sound like thunder everlastingly
Dear child! dear girl! that walkest with me here,
If thou appear untouched by solemn thought
Thy nature is not therefore less divine:
Thou liest in Abraham's bosom all the year,
And worship'st at the Temple's inner shrine,
God being with thee when we know it not.

WILLIAM WORDSWORTH

Above left
Terry O'Donnell
Wedding invitation. 6″ × 4¼″ (15 × 11 cm).
1980

Above right
Brody Neuenschwander
To Autumn by John Keats. Written out with
a quill and black gouache on vellum, with
raised and burnished gold initials. Stretched
over prepared board after writing.
31¼″ × 21″ (79.5 × 53.5 cm). 1985

Left
Susie Taylor
Sonnet by William Wordsworth. Written
out with a Mitchell Rexel pen in white
gouache on blue Fabriano Ingres paper.
14″ × 11″ (35.5 × 28 cm). 1984

Opposite page
David Mekelburg
Happy Birthday, Miriam. Spontaneous piece
of writing done in an afternoon for a
friend's birthday. On Frankfurt etching
paper with steel pens, stick ink and
designers' gouache. 30″ × 21″
(76 × 53.5 cm). 1982

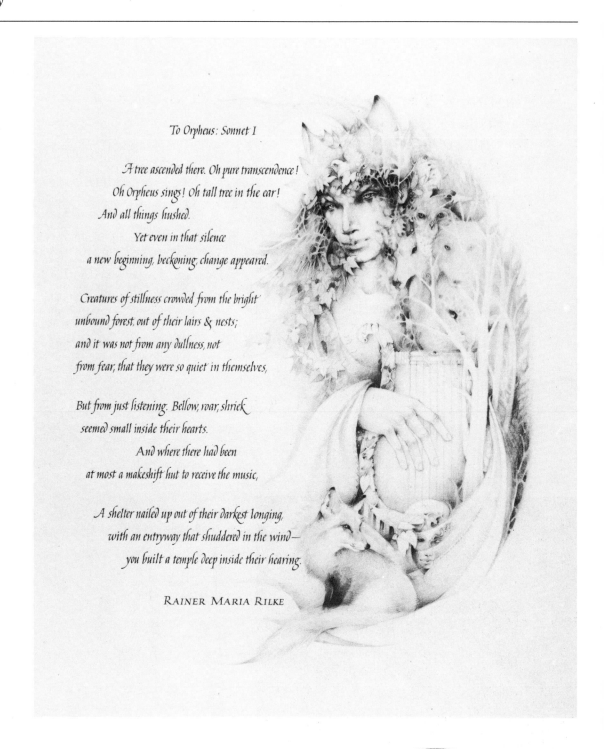

To Orpheus: Sonnet 1

A tree ascended there. Oh pure transcendence!
Oh Orpheus sings! Oh tall tree in the ear!
And all things hushed.
 Yet even in that silence
a new beginning, beckoning, change appeared.

Creatures of stillness crowded from the bright
unbound forest, out of their lairs & nests;
and it was not from any dullness, not
from fear, that they were so quiet in themselves,

But from just listening. Bellow, roar, shriek
seemed small inside their hearts.
 And where there had been
at most a makeshift hut to receive the music,

A shelter nailed up out of their darkest longing,
with an entryway that shuddered in the wind—
 you built a temple deep inside their hearing.

RAINER MARIA RILKE

Alegría y felicidades en la Semana de la Secretaria

Fritz Eberhardt
Quotation from Goethe. Written in black
ink on ivory-coloured Royal vellum rag
paper, the attribution in red. $19\frac{1}{2}'' \times 24\frac{1}{2}''$
$(49.5 \times 62\,\text{cm})$.
(In the possession of Rick Cusick.)

Left
Julian Waters
Lettering for a printed poster. Written with
a broad steel pen and black ink.

Opposite page, above
John Prestianni
Sonnet 1 from *Sonnets to Orpheus* by
Rainer Maria Rilke, translated by
Stephen Mitchell. Written out in ink and
colour on Fabriano paper. Drawing in
graphite and coloured pencil by Susan
Seddon Boulet. $23'' \times 19''$
$(58.5 \times 48.5\,\text{cm})$. 1986

Opposite page, below
Egdon Margo
Greetings in Spanish

Things Men have made with wakened hands and put soft light into are awake through years with transferred touch and go on glowing for long years and for this reason some old things are lovely warm still with the life of forgotten men who made them

D·H·LAWRENCE

Above
Sheila Waters
Things men have made. Stick ink on Green's handmade paper with gilded dots and parts of initial letter. 21″ × 14″ (53.5 × 35.5 cm). 1984

Opposite page
Sheila Waters
October by Robert Frost. Swiftly and freely written out in stick ink on white handmade paper, with No. Speedball C Series pen. 24″ × 18½″ (61 × 47 cm). 1985
(Commissioned by Joanne Fink.)

O hushed October Morning Mild,
Thy leaves have ripened to the fall;
Tomorrow's Wind, if it be wild,
Should waste them all.
The crows above the forest call;
Tomorrow they may form and go.

O hushed October Morning Mild,
Begin the hours of this day slow,
Make the day seem to us less brief.
Hearts not averse to being beguiled,
Beguile us in the way you know.

Release one leaf at break of day,
At noon release another leaf;
One from our trees, one far away.

Retard the sun with gentle mist;
Enchant the land with Amethyst.
Slow, s·l·o·w!
For the grapes' sake, if they were all,
Whose leaves already are burnt with frost,
Whose clustered fruit must else be lost—
For the grapes' sake
Along the wall.

The essence of beauty in writing
is not to be found in the written word
but lies in response to unlimited change;
line after line should have a way
of giving life, character after character
should seek for life-movement.

ANONYMOUS CHINESE SCRIBE · Written out by David Mekelburg February 1982

Above
David Mekelburg
The Essence of Beauty. Quotation from an anonymous Chinese scribe. Wall panel written with steel pens and stick ink on Whatman handmade paper. 18″ × 24″ (46 × 61 cm). 1982

Right
Julian Waters
Slogan for a printer. Written with a quill on coated paper. Black ink.

The Garamond Pridemark Touch ·

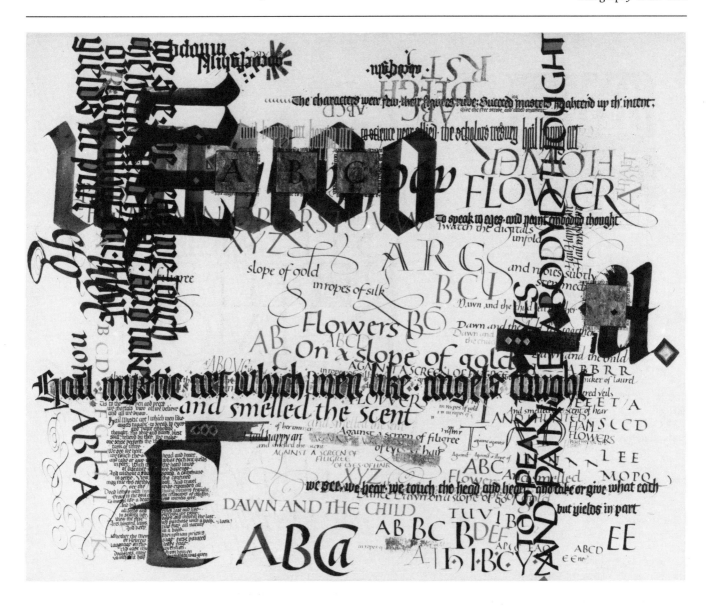

Above
Thomas Ingmire
'Calligraphy Play' including quotations
from *Hail Mystic Art* by J Carstairs.
18½″ × 23″ (47 × 58.5 cm). 1986

Left
Julian Waters
Poster lettering. Written with a broad steel
pen and black ink.

Above
Rick Cusick
Book plate for Richie Tankersley Cusick.

Rick Cusick
Mark for Glenn Books, Inc.

Right
John Stevens
Calligraphy for a Bible Book (Epistle to
the Hebrews) for Professor Donald
Knuth of Stanford University,
California. Black stick ink on white
Langley handmade paper, with
highlights in red. $5\frac{1}{2}''$ (14 cm) wide. 1986

Right
John Prestianni
Experimental writing with a steel pen
and black ink on paper. Reduced to $\frac{1}{3}$
actual size. 1986

The soul
becomes
dyed
with the
color
MARCUS
AURELIUS of its
thoughts.

שלום על ישראל

FROM THE INCOME
OF THE BEQUEST OF
LEE M.
FRIEDMAN '93

VE RI
TAS Harvard College
Library

HARVARD UNIVERSITY
3·⊂ *Dumbarton Oaks Library*

QUARTET

Top left
Rick Cusick
Marcus Aurelius quotation printed as a
personal New Year greeting for 1986.
Written with a Brause pen and
reproduced by offset lithography, in
dark grey ink on light grey paper. 1985

Top right
Rudolf Ruzicka
Book plates

Bottom
John Prestianni
Quartet. Hand-drawn brush lettering for
use as a watermark in handmade paper,
specially made for a fine press edition of
essays. Actual size. 1986

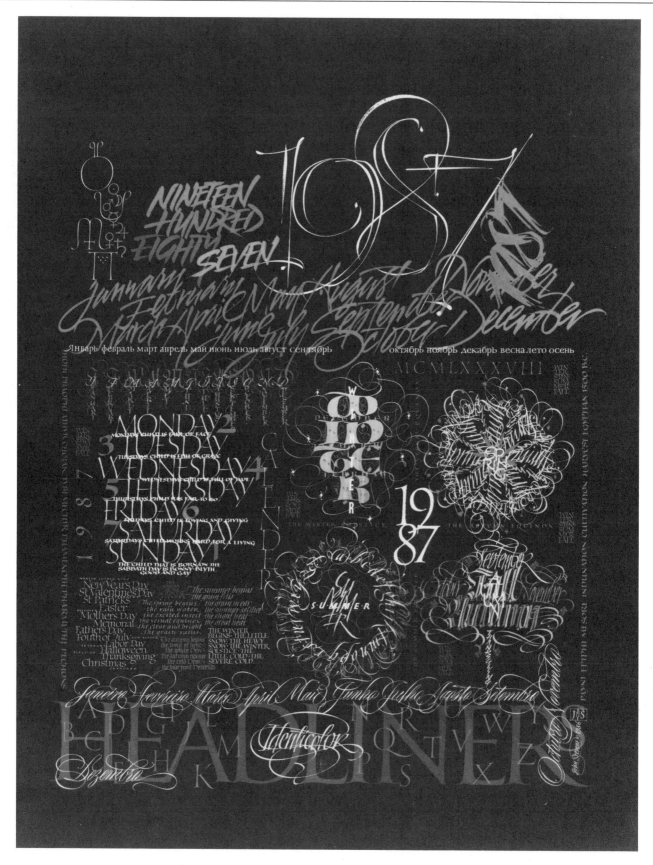

John Stevens
1987 Headliners Calendar/Poster. Written with brush, pen and various media on black
Canson paper. 25″ × 19″ (63.5 × 48.5 cm). 1986

Calligraphy in America: a personal viewpoint.

Sheila Waters

Sheila Waters a dynamic calligrapher and talented artist, is notably well qualified to write an account of the craft in America. English born she has had wide experience of calligraphy and lettering in the book arts, in graphic design and in the production of sumptuous and compelling manuscripts. Since her family moved to America she has been a leading influence as a teacher through the workshops, lectures and courses she has conducted for calligraphy societies and educational institutions throughout the USA and Canada since 1972.

Her husband Peter, is a well known bookbinder and conservator, her eldest son Julian, also a freelance calligrapher, designed the jacket for this book.

Background

American calligraphy this century has been considered more experimental than British because its predominant usefulness has been different. In Britain, emphasis has been laid on the use of calligraphy for formal purposes, such as ceremonial occasions, so the work of British scribes has shown a more formal approach to layout and letter style, even when designed for commerical use.

In the USA the predominant uses for calligraphy have been in the commercial field. Ray DaBoll, George Salter and James Hayes come to mind as examples of calligraphers who were also designers, producing a constant flow of lively work to serve a wide variety of commerical needs decades before the grass roots revival which developed so rapidly in the seventies. Demand for ceremonial pieces is limited except for one significant area, that of Hebrew ketubas (Jewish wedding agreements). These require Hebrew script with optional English translation and are usually decorated with wide, rich borders. One-off awards and tributes are mostly supplied by the engrossing trade studios which still specialize in Victorian-style writing and illumination, although calligraphers have encroached upon this market to a limited extent, especially for more modern interpretations. At ground base, freelance employment exists for the filling in of names on typeset certificates, the addressing of envelopes, designing of local flyers and invitations, spiced by occasional demand for wall panels of poems and quotations. Partially-trained part-time scribes cope with the bulk of this type of work which epitomizes 'calligraphy' in the public mind. Few professional calligraphers can earn a total living from their art/craft and it is usually supplemented by teaching.

Calligraphy as fine art

Calligraphy as fine art is rarely understood or patronized by either the general public or even the art-conscious public, although there are signs of gradual awareness, probably due to an increasing number of exhibitions set up by local societies displaying every aspect of the subject. Calligraphy may be regarded as being in a similar situation as photography was just a few decades ago. The possibilities of photography as fine art are now recognized. It is to be hoped that fine calligraphic art may eventually achieve similar recognition in the fine art world.

In this last quarter of the twentieth century, developments in calligraphy have taken place which differ greatly from those in the past. The differences are mainly those of scale, use, and expectation. Historical writing was designed for the practical use of being read from a lectern or in the hand and certainly not across a room from a wall. Nor was it expected to express any emotional content of the author's words by means of its style and design. Today we not only try to add depth of meaning to an author's words but attempt 'self expression', often in abstract terms through letterforms, sometimes in conjunction with painterly techniques, use of color, and devices that are integral to the letterforms themselves and not necessarily traditional in form or supported by illustration. This is an extremely challenging area, represented by artists such as Thomas Ingmire and Dick Beasley.

There is a new approach to tools and materials. From early to mid twentieth century there was an emphasis on the methodology of the teaching of the craft in traditional ways. This was necessary in order to re-establish long-lost criteria for standards of

workmanship, techniques and planning. Therefore exploration and innovation were not too actively encouraged. Now, boundaries are being extended and broken, in concepts and in practice. New techniques are tried and taught, new materials and tools are invented and developed. Techniques are used to create interesting textures and patterns with letters. Colored writing is used in exciting ways, not just in opaque color to highlight important lines or words, but in combination with washes and illustration. Transparent, waterproof colored inks, hitherto subject to fading, are now being claimed as light fast and therefore are being used more widely. Edges of letterforms are no longer 'correct' only if they are smooth and crisp but can be rough and broken if appropriate. Atmosphere is now of more importance. Letters are used to set a mood, whether sad or happy, solemn or light-hearted and actively express feelings such as joy, fear, peace, anger.

The pen is freely manipulated in various ways. Weight of stroke and refinement of serif are controlled much more sensitively than is possible by the rigid maintaining of a fixed pen angle. The 'sleight of hand' spoken of by Edward Johnston has become much more strongly marked and three methods are now used quite widely, all having historical precedent. These are: subtle changes in the angle of the nib's edge throughout a stroke, 'cornering' by drawing part of a stroke or serif with a corner of the nib only, and variations of pressure.

There is a challenge in knowing where to 'draw the line' between legibility and the lack of it. But wherever it is drawn it remains evident that soundness of underlying form is very important. However loose and free or even 'distorted' letters become in being part of an atmospheric whole, it still shows if the artist has an understanding of traditional letterform structure based on historical precedent, also a good sense of balance, proportion, use of negative space, interesting grouping, good craftsmanship and confident handling of tools and materials. After all, works of art are produced by artists, which is true not only of painting but also of calligraphic art. Unfortunately, as in other art forms, many aspiring artists are too concerned with stylistic superficiality. There is far too much preoccupation with imitating the mature styles of well-known artists rather than conducting a personal search for significant form. The latter route implies a growing understanding of the inner structure of letters, their arrangement and presentation, so that personal style and originality will grow out of depth of study and objective work.

It is encouraging to note that the importance of using archivally-sound materials both for the calligraphy itself and for its matting (mounting) and framing is now quite widely recognized.

Sheila Waters
Winter greeting card, which will carry her through to March. Original written with a felt marker and printed on her own Canon copier at minimum cost! $5\frac{1}{4}'' \times 7\frac{1}{2}''$ (13.5 × 19 cm). 1986

Calligraphy in graphic art

In the wide field of graphic communication calligraphy has been gaining acceptance as having occasional sales potential. A greater respect for handwritten and drawn letterforms has been encouraged in particular by the efforts and exhibitions of the International Typeface Corporation of New York City, working closely with Hermann Zapf. In recent years more art directors have commissioned hand lettering, especially for headlines, captions and logotypes. Free, rough-edged energetic styles are preferred because of their greater contrast to type. Representative of leading designers influencing this aspect of calligraphy and lettering are Rick Cusick at Hallmark Cards in Kansas, Georgia Deaver in San Francisco, Tim Girvin in Seattle, Rich Lipton in Boston, John Stevens in New York and Julian Waters in Washington, D.C. In addition, greeting card companies show an increasing use of well-written calligraphy which brings it into thousands of stores and homes.

Training

Calligraphy had already been alive and well in the predominant centres of Chicago, New York and San Francisco in the mid twentieth century. Because such a base already existed and a renewed interest was beginning to grow across the U.S. in the mid-seventies, it was natural that Donald Jackson's early tours made him a catalyst and prepared the way for many societies to grow very rapidly, especially in New York City and Los Angeles. In the Washington D.C. area, I had initiated classes for the Smithsonian Institution in 1972, later taught privately and trained most of the local teachers for about six years, until I too became one of a growing number of itinerant teachers engaged to present workshops and lectures for societies in major cities in the U.S. and Canada. Such groups now number well over one hundred, and their activities, workshops and classes are probably the strongest continuing influence on aspiring calligraphers.

Overall there is little systematic and structured teaching in the sense of on going courses, compared with art school courses available prior to the fifties. Most training is gained in bits and pieces, and at the local level in many cases students are being taught by insufficiently knowledgeable teachers with no certification. No generally-accepted standards have been laid down, and of the textbooks available the poorest seem to have the widest circulation. But in spite of all the difficulties met with in acquiring any kind of comprehensive training, much excellent work has been achieved. This is evident at exhibitions, both regional and national, which show work of an increasingly high standard. Those who are highly motivated have sought further instruction, so that in the past few years the number of intensive courses available has proliferated. These courses, of from one day to two weeks' duration, are rarely supported by an educational institution. Some are privately organized and directed by a professional calligrapher offering nation-wide enrolment, but most are arranged by societies who employ a travelling teacher for the benefit of local members. At present, this is the best that can be achieved, but it is frustrating for both student and teacher because no follow-up commitment by the teacher is possible. Information tends to be given in concentrated doses and out of a normal systematic order so students are prone to fail to grasp the fundamentals of the craft aspect of calligraphy. Many are inspired by the professional work they see in books and exhibitions and are tempted to try to fly before they can walk in the name of 'creativity' and 'self expression'.

The international calligraphy conference in 1986, held in New Jersey, was named 'Innovations' and every possible innovation and creative endeavor was represented. But it is interesting to note that a questionnaire put forth by the Calligraphy Idea Exchange magazine (a worthy publication in full color which has been a national, even international showcase) has shown that students are wanting more of the basics, realizing that too much freedom without the underpinning of sound knowledge and structure seems futile. This seems to be a healthy direction, pointing to a good balance being achieved in the future.

Annual conferences have been another strong influence. Each summer since 1981 a one-week conference of between 450 and 600 calligraphers has been hosted by calligraphic societies in major cities throughout the U.S. The concept was originated by Jo White of the Minneapolis/Saint Paul society, The Colleagues of Calligraphy, which has hosted two conferences, in 1981 and 1984. In 1982 the meeting ground was in Philadelphia, 1983 in Chicago, 1985 in Los Angeles and 1986 in Hoboken, New Jersey. The society in Portland, Oregon will be host in 1987 and the Washington D.C. Guild will follow in 1988. These conferences have become family gatherings for the faculty, who sometimes number 75 teachers. Workshops, lectures, demonstrations and exhibitions are arranged, allowing students from many countries to meet with each other and focus fully on calligraphic specialties. Naturally the emphasis so far has been on breadth of interest and exposure rather than on in-depth study and cannot take the place of more concentrated courses. But the benefits seem to be very positive. Both conferences and

courses are a strong force in cementing contacts between hundreds of aspiring and professional calligraphers, encouraging exchange of news and ideas, especially for people who live in isolated areas where little contact or help is possible.

So much for comments on the training available in the private sector. The situation within art schools on the other hand seems to have improved little during the past 15 years, with a few exceptions. Prior to the mid-fifties, lettering, both written and drawn, was a required subject in any graphic art training and was often given to those majoring in the fine arts. Somehow an attitude of contempt for the subject grew on both sides of the Atlantic and calligraphy was abandoned as being an anachronism and therefore irrelevant to the training needed for industry. While studying at the Royal College of Art, London, I vividly remember calligraphy being referred to by members of the design faculty as 'Mrs. Mahoney's knitting'. At the present time art students working across the road from the famed Klingspor Museum in Offenbach, Germany, which houses the works of great twentieth-century calligraphers such as Rudolf Koch, Rudo Spemann, Ernst Schneidler and Karlgeorg Hoefer, are actively discouraged from doing any research in the museum. It may take many years for art education administrators to recognize that calligraphy and lettering have something of great value to offer and can be taught in a lively way, totally relevant in application to modern technological and visual needs, especially as it has now been more widely used.

New Technologies

Technology is developing at an ever-increasing pace in the graphic arts and type design fields, especially in the use of computers. So many well-known typefaces in general use were designed by those who were well trained in the history and techniques of writing, such as W Dwiggins, George Trump and Hermann Zapf. The latter still leads the way in encouraging the type design industry to be aware of the danger that if technology is not tempered, even directed by the aesthetic values and high standards of our past, degeneration into an aesthetic chaos of letterforms will be inevitable, governed only by what sells in the market place.

But calligraphy itself is not immune to the progress of technology. Recently computers have been harnessed to calligraphy in such a way that envelopes can be calligraphically addressed with a normal ink-filled fountain pen fitted with a broad-edged nib, held by a mechanical device which is directed in its movements by a computer program, the address being typed on a word processor by an operator who is unskilled as a scribe. At present there are problems of letter spacing, and natural changes of pen angle within a 'fount' are not yet developed, but these refinements will inevitably come. The manufacturer knows that the product can never compete with fine calligraphy but it may certainly take over the more tedious chores of addressing, filling-in of names and even setting out personalized invitations and annoucements, the bread and butter work of calligraphers of most levels. Fortunately it is only the poorest amateur level that this kind of technology may put out of business. This particular technique is in place and being sold, so cannot be ignored. It will proliferate good or bad alphabets according to whoever designs for it within its limitations. It could even be an asset in raising the standard of quality rather than lowering it.

All of the present-day fast -moving developments emphasize the need for sound guidance at the training stage of every young professional who will have to work with letterforms and also the need to narrow the gaps dividing their specialties. To meet this need calligraphy and lettering design should again become a respected and essential subject in college and art school curricula, so that training and technology can proceed hand in hand. At present it is difficult to see how this can come about but trends are pointing in that direction. It is to be hoped that the schism between art schools and calligraphy which began thirty years ago will not take another thirty years to mend.

On the whole calligraphy is very healthy in America; there is an excitement and vitality about it which is exhilarating for those of us who are a part of its continuing development.

A note on the Eastern influence

T he growing influence of Eastern scribes, particularly in their valuation of the art of calligraphy – its meaning and purpose – is in strong contrast to the Western view of the craft.

In China calligraphy has historically been held in almost reverential respect and even Emperors were anxious to be thought worthy scribes. Widespread critical expertise among the educated raised the standard of artistic and manual skills. Buddhist scriptures inspired noble examples of calligraphy in many regional scripts, so finely described in John Steven's *Sacred Calligraphy of the East*. Yet the arts of writing and painting were both performed with the brush – an economy of means that laid stress on rhythm and vitality. While modern Western scribes do not yet command the same esteem there is a growing belief that calligraphy can be an art as satisfying as painting and still has heights to climb in public appreciation.

In the Middle East, the Jews, the Christians and the Moslems are called the Children of the Book. As in all great religions with written scriptures, the work of the scribe is honoured as repository and record. The richest materials and most beautiful scripts have been used to do homage to the sacred texts. They were written with an edged tool – reed, quill or pen rather than brush.

Islamic art early turned away from figurative representation and towards mathematical and abstract forms. The central importance of the Koran used calligraphy not only to convey the written word but as splendid architectural and mural decoration. Arabic scripts can be of outstanding beauty and some Koranic manuscripts rank among the pinnacles of the art.

It is good to know that this traditional penmanship is still being demonstrated and taught; the dramatic work of Hassan Massoudy, who is a calligrapher and teacher in Paris, is illustrated in both traditional and expressive form among the reproductions in this book.

Present-day Japanese brush writing has encouraged a simplicity of statement and freedom of gesture that have visibly influenced a number of modern American and European scribes. And not scribes only. In the recent past, this concept of freedom also moved certain abstract artists towards the so-called Calligraphic Painting, best epitomised perhaps by Jackson Pollock's work and Mark Tobey's 'white writing'.

The idea – borrowed from the East – that artists can 'write a painting' has made it more acceptable for calligraphic work to be considered primarily as visual aesthetic statement and not essentially as a means of communication through the written word. A good deal of current practice springs from this vigorous seed.

Greeting from a Japanese calligrapher.
1976
(In the possession of Heather Child.)

Previous page
Chinese poem by Ho Sze Ko, written with a fox-hair brush and stick ink on white rice paper.
A poem is a painting with sound
A painting is a poem without sound.
Height of original 18″ (45.5 cm).
(In the possession of Ann Hechle.)

Opposite page, above
Hassan Massoudy
'Freedom' in Arabic script. Written with a reed pen in brown ink on white paper. 19″ × 24″
(48.5 × 61 cm). 1983
(In the possession of Jana Gough.)

Opposite page, below
Hassan Massoudy
Two Arab proverbs: 'A single hand cannot clap' printed sepia on white, and 'Do not use two words if one will do', reversed white out of sepia.

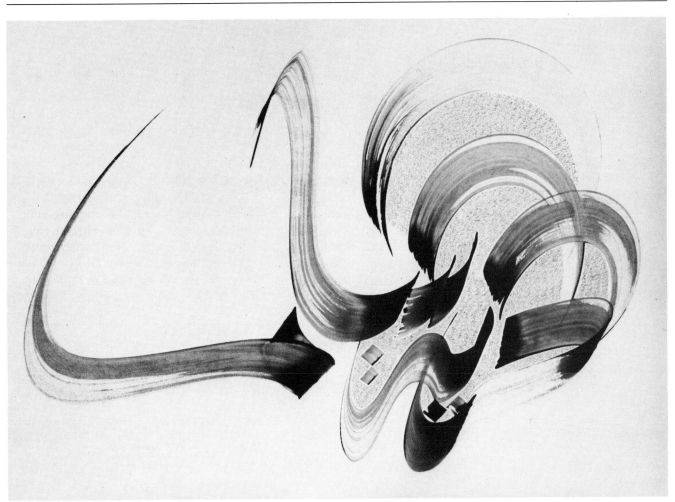

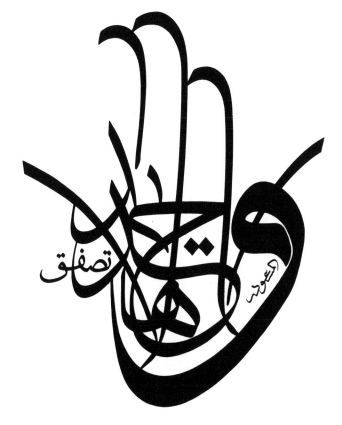

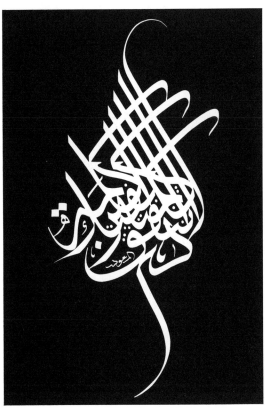

Select bibliography

Donald M Anderson — *The Art of Written Forms: the Theory and Practice of Calligraphy*, Holt, Rinehart and Winston, New York 1967

Marie Angel — *The Art of Calligraphy*, Robert Hale 1978
Painting for Calligraphers, Pelham Books 1984

Sylvia Backemeyer and Theresa Gronberg (ed.) — *W R Lethaby 1857–1931: Architecture, Design and Education*, catalogue for exhibition at Central School of Art and Design, Lund Humphries 1984

Janet Backhouse — *The Illuminated Manuscript*, Phaidon 1979
The Lindisfarne Gospels, Phaidon 1981

John Howard Benson — *The First Writing Book: Arrighi's 'La Operina'*, Oxford University Press 1955

John Howard Benson and A C Carey — *The Elements of Lettering*, McGraw-Hill, New York 1940

T A M Bishop — *English Caroline Minuscule*, Oxford University Press 1971

John Brinkley (ed.) — *Lettering Today*, Studio Vista, London 1964

Ann Camp — *Pen Lettering*, revised edition, A & C Black, London 1984

Edward M Catich — *The Origin of the Serif: Brush Writing and Roman Letters*, Catfish Press, St Ambrose College, Davenport, Iowa 1968
Reed, Pen and Brush Alphabets for Writing and Lettering: Portfolio of 27 Alphabets with descriptive book, Catfish Press, St Ambrose College, Davenport, Iowa 1968

Heather Child — *Heraldic Design*, Bell & Hyman 1979

Heather Child (ed.) — *The Calligrapher's Handbook*, A & C Black 1985 (USA: Taplinger)

Heather Child, Heather Collins, Ann Hechle and Donald Jackson — *More than Fine Writing: Irene Wellington, Calligrapher (1904–84)*, Pelham books, London 1986

Rick Cusick (ed.) — *With Respect... to RFD*, an appreciation of Raymond Franklin DaBoll and his contribution to the letter arts, with a foreword by James M Wells, TWB Books, Woolwich, Maine 1978

John Dreyfus — *The Work of Jan van Krimpen*, Sylvan Press, London 1952

Alfred Fairbank — *A Book of Scripts*, Penguin, Harmondsworth 1949; Faber, London 1979
A Handwriting Manual, revised edition, Faber, London 1975

Alfred Fairbank and Berthold Wolpe — *Renaissance Handwriting*, Faber, London 1960

Rick Cusick
Stylist Emeritus. Design for an award, the lettering to be cut in brass. 1986
(© Hallmark Cards, Inc. Art Director: Don Dubowski.)

124

William Gardner	*Alphabet at Work*, A & C Black 1982 (USA: St Martin's Press)
Tom Gourdie	*Calligraphy for the Beginner*, A & C Black, London 1983 (USA: Taplinger) *Italic Handwriting*, Studio Vista, London 1963; Pentalic, New York 1974
Nicolete Gray	*Lettering as Drawing*, Oxford University Press 1971
George Haupt	*Rudolph Koch der Schreiber*, Insel Verlag, Leipzig 1936
James Hayes	*The Roman Letter* Chicago 1951; reprint 1983
Graily Hewitt	*Lettering*, Seeley Service, London 1930 *Handwriting: Everyman's Craft*, Kegan Paul, Trench, Trubner, London 1938
Philip Hofer	*John Howard Benson and his Work*, The Typophiles, New York 1957
C G Holme (ed.)	*Lettering of Today*, essays by Anna Simons, Percy Smith and Alfred Fairbank, Studio Books, London 1937 and 1941
Rathbone Holme and Kathleen M Frost (ed.)	*Modern Lettering and Calligraphy*, Studio Publications, London 1954
Donald Jackson	*The Story of Writing*, Studio Vista, London 1981, now Trefoil Books (USA: Taplinger) Paperback edition, Barrie & Jenkins, London 1987
Edward Johnston	*Writing and Illuminating, and Lettering*, John Hogg, London 1906; later editions Pitman, now A & C Black (USA: Taplinger) *A Book of Sample Scripts*, HMSO, London 1966 (ed. Heather Child) *Formal Penmanship and Other Papers*, Lund Humphries, London 1971 (ed. Heather Child and Justin Howes) *Lessons in Formal Writing*, Lund Humphries, London 1986 (USA: Taplinger)
Priscilla Johnston	*Edward Johnston*, Faber, London 1959; Barrie & Jenkins, London 1976
Walter Kaech	*Rhythm and Proportion in Lettering*, Otto Walter, Olten-Verlag, Switzerland 1956
Stan Knight	*Historical Scripts: a handbook for calligraphers*, A & C Black 1984 (USA: Taplinger)
Rudolf Koch	*Das Schreibbuchlein*, second edition, Barenreiter-Verlag, Kassel 1935
C M Lamb (ed.)	*The Calligrapher's Handbook*, Faber, London 1956 (see also 1985 Handbook under Heather Child)
Erik Lindegren (ed.)	*ABC – and ABC Book*, Pentalic 1976, now available from Taplinger

Donald Jackson
Shopping bag design for a Calligraphy Conference.

Donald Jackson
Grønne Buffet card for Cranks restaurant. Printed in apple green on white.

Stuart Barrie
Drawn lettering design for a Christmas card. 8¾″ × 4″ (22 × 10 cm). 1984

E A Lowe	'Handwriting' in *The Legacy of the Middle Ages*, ed. C G Crump and C F Jacob, Oxford University Press 1951 *English Uncial*, Oxford University Press 1960
Byron J Macdonald	*The Art of Lettering with the Broad Pen*, Van Nostrand Reinhold, New York 1966; Pentalic, New York 1973
Dorothy Mahoney	*The Craft of Calligraphy*, Pelham Books, London 1981 (USA: Taplinger)
Dorothy E Miner Victor I Carlson and P W Filby (ed.)	*Two Thousand Years of Calligraphy*, catalogue of the 1965 Calligraphy Exhibition in Baltimore, Walters Art Gallery, Baltimore, Maryland 1965; Pentalic 1980, now available from Taplinger
Stanley Morison	'Calligraphy' in *The Encyclopaedia Britannica*, fourteenth edition 1945
Alexander Nesbitt	*Lettering: the History and Technique*, Prentice-Hall, New York 1950
Friedrich Neugebauer	*The Mystic Art of Written Forms*, Neugebauer Press 1980
Oscar Ogg (ed.)	*Three Classics of Italian Calligraphy*, facsimiles of the writing books of Arrighi, Tagliente and Palatino, Dover Publications, New York 1953
A S Osley (ed.)	*Calligraphy and Palaeography*, Faber, London 1965
Ieuan Rees and Michael Gullick	*Modern Scribes and Lettering Artists*, Studio Vista 1981; Trefoil Books 1983
Lloyd J Reynolds	*Italic Calligraphy and Handwriting*, Pentalic, New York 1969
LLoyd J Reynolds	*Straight Impressions*, with an introductory note by Rick Cusick, TWB Books, Woolwich, Maine 1979
Percy J Delf Smith	*Civic and Memorial Lettering*, A & C Black, London 1946

Stuart Barrie
Lettering painted in three colours and black on Saunders paper with a prepared ink background. Designed for Taplinger Calendar 1987. 11″ × 9″ (28 × 23 cm).

ACCENDAT · IN · NOBIS DOMINUS IGNEM · SUI · AMORIS

Edward Maunde Thompson	*Introduction to Greek and Latin Palaeography*, Clarendon Press, Oxford 1912
Jan Tschichold	*An Illustrated History of Writing and Lettering*, Zwemmer, London 1946 *Treasury of Alphabets and Lettering*, Reinhold Publishing Corporation 1966
B L Ullman	*Ancient Writing and its Influence*, Cooper Square Publishers, New York 1930; M I T Press, Cambridge, Massachusetts 1969
James Wardrop	*The Script of Humanism*, Oxford University Press 1953
Irene Wellington	*The Irene Wellington Copy Book*, omnibus edition, Pitman, London 1977, now available from A & C Black (USA: Taplinger)
Hermann Zapf	*About Alphabets*, some marginal notes on type design, The Typophiles, New York 1960 Foreword in *International Calligraphy Today*, Thames & Hudson, London 1982

John Woodcock
Cover design for *The Calligrapher's Handbook*, edited by Heather Child for the SSI (Taplinger, New York). 24.5 × 19 cm (9¾ × 7½"). 1985

Index